POSTCARD HISTORY SERIES

Fort Myers

IN VINTAGE POSTCARDS

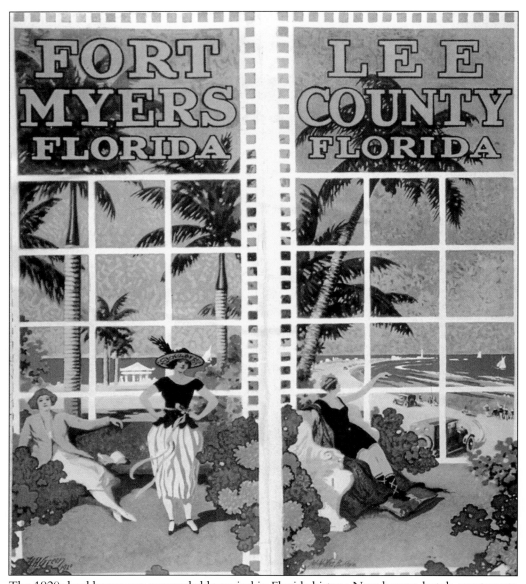

The 1920s land boom was a remarkable period in Florida history. New houses, hotels, apartments, and commercial buildings were constructed in record numbers, as were countless municipal projects. Even new cities surfaced, such as Boca Raton, Hollywood, Coral Gables, and Venice. Tourists and newcomers poured in as never before, attracted by get-rich-quick real-estate stories and seductive brochures like the above. Choice real-estate parcels in Fort Myers often changed hands several times in a single day. Eventually two hurricanes hit Florida, the stock market crashed, and a state banking crisis halted the speculative fever.

POSTCARD HISTORY SERIES

Fort Myers

IN VINTAGE POSTCARDS

Gregg Turner

ARCADIA
PUBLISHING

Published by Arcadia Publishing
Charleston, South Carolina

Printed in the United States of America

Library of Congress Catalog Card Number: 2005921537

For all general information contact Arcadia Publishing at:
Telephone 843-853-2070
Fax 843-853-0044
E-mail sales@arcadiapublishing.com
For customer service and orders:
Toll-Free 1-888-313-2665

Visit us on the Internet at www.arcadiapublishing.com

For Koko, my wonderful office assistant

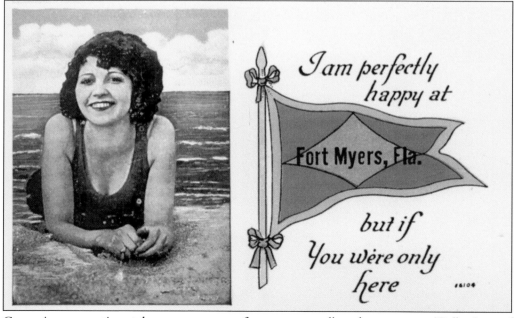

Conveying a sentimental message was often a postcard's sole purpose. (Collection of Sara Nell Gran.)

CONTENTS

ACKNOWLEDGMENTS

This visual retrospective is really a companion piece to another book I did on Fort Myers with Stan Mulford. It was released by Arcadia Publishing in 2000. The earlier volume recounts the city's past using historic images and text; this one utilizes antique postcards, period brochures, maps, etc., from roughly 1890 to the 1960s.

Several persons made this book possible, and I would like to acknowledge the help of Sara Nell Hendry Gran, whose pre-eminent postcard collection of Fort Myers and Lee County could fill several books. Thanks are also owed to Stan Mulford, noted historian of Fort Myers, and to Matt Johnson, general manager of the Southwest Florida Museum of History. I am also indebted to the staffers of the Florida State Photo Archive in Tallahassee, and my gifted editor at Arcadia, Barbie Langston.

To one and all I extend my sincerest appreciation!

Gregg Turner
GreggTurner@msn.com

A happy scene of yesteryear was composed at Fort Myers Beach. (Collection of Sara Nell Gran.)

INTRODUCTION

There is only one Fort Myers, and ninety million people are going to find it out.

—Thomas Edison

Postcards have had a long and fascinating history in America, and the numbers of people that collect them today are legion. Although they appeared in other countries after the American Civil War, their usage in the United States did not really begin until the 1870s. The United States Congress authorized "private mailing cards" in May 1898. Three years later, the government allowed the words "Post Card" to be printed on the undivided backside of privately printed cards; thus, senders had to write their messages on front, as several examples in this book illustrate. Then, in 1907, the United States government sanctioned postcards with a divided backside: half could be used for the message, the remaining half for the recipient's address, while the front of the card could be entirely devoted to an image. The cards themselves were often printed abroad, especially Germany, where printing technology excelled. Between 1916 and 1930, most cards embraced a white border around the image. Linen stock came into use in 1930, and many postcards were produced in bright and vivid colors. Later, in 1939, "photochrome" postcards came of age, which are still in use today.

It is not known when the first postcard appeared about Fort Myers, nor what the subject matter was, who produced or sold it, to whom it was sent, or what the postcard may have cost. But what is known is this: that the golden age of postcards started around the very time that Fort Myers was shedding its image as a frontier cow town. Since the late 19th century, literally hundreds of different postcards about the City of Palms have been produced. The arbitrary selection between these pages can only hint at the fabulous variety that has been issued.

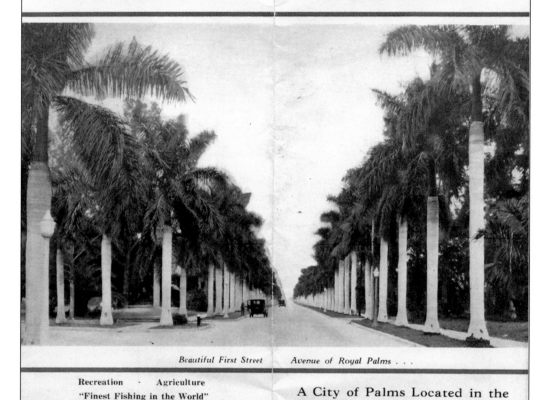

FORT MYERS FLORIDA

FORT MYERS FLORIDA

Beautiful First Street

Avenue of Royal Palms . . .

Recreation · Agriculture
"Finest Fishing in the World"
Fort Myers . . in Tropical Lee County, Florida

A City of Palms Located in the Semi-Tropics of Southern Florida

Although picturesque McGregor Boulevard in Fort Myers is known throughout the world, First Street was even more splendid in its heyday. Both sides of the brick-paved artery were lined with towering royal palms and streetlights, as this 1932 brochure confirms. It was nicknamed "Millionaire's Row," because many stately homes fronted the busy thoroughfare. In that year, the population of Fort Myers stood at 10,000, "with hotel and rooming facilities for an additional 5,000 persons." The assessed valuation had increased from $5.8 million in 1920 to $15 million.

One

SO LONG AGO

Fort Myers may boast of perhaps 100 residents and has two or three good stores and a few private dwellings.
Its appearance is decidedly tropical. Orange trees had their boughs laden down with the golden fruit and the
cocoanut palms bore their clusters of great brown nuts. Visiting the stores for the sake of provisioning our craft,
the business of Fort Myers was at once discernable from the array of saddles and bridles exhibited.
 —*New York Times*, May 3, 1884

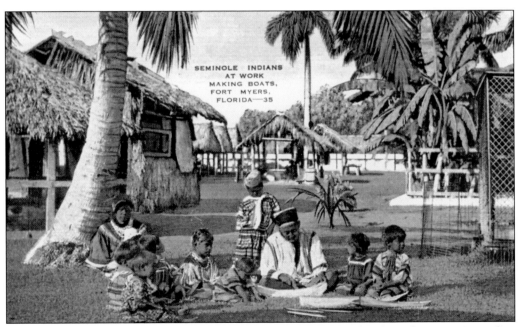

The history of the Seminole tribe is one full of heroism, tragedy, and pathos. The expensive Indian removal campaigns in Florida were not completely successful, and in the end, hundreds took refuge in the Everglades. They occasionally ventured into Fort Myers to trade and sell their wares, but never to live.

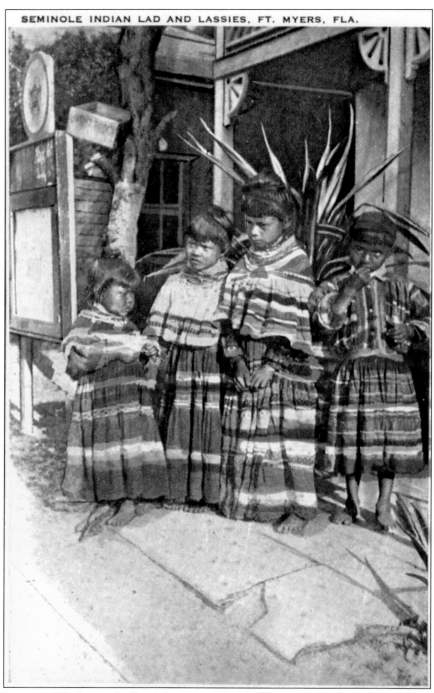

SEMINOLE INDIAN LAD AND LASSIES, FT. MYERS, FLA.

In 1909, some 625 Seminole lived in lower Florida. They steadfastly refused United States government money or land, nor would they accept school funds. The trips to Fort Myers—to trade and buy—were really family outings. Kids wore no shoes, but their garments were highly colorful, artful creations.

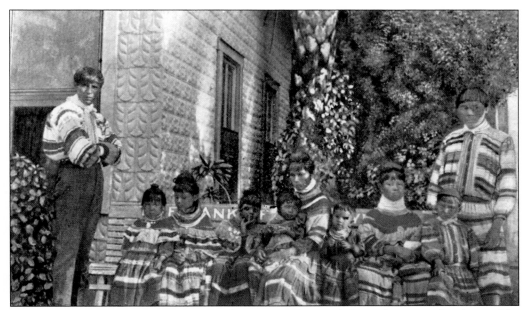

Capt. Francis Asbury Hendry—"Father of Fort Myers"—cared about the Seminole. The wealthy cattleman helped get a 5,000-acre state reservation for them in the Everglades. He even educated a Seminole boy at his home—Billy Corn Patch, the first of the tribe to receive such. Hendry's great granddaughter, Sara Nell Hendry Gran, provided many postcards for this book.

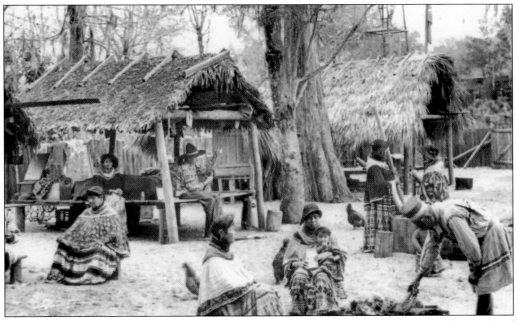

Seminole living conditions in the Everglades were basic and functional. Here they hunted and fished in peace. Meals were cooked outdoors, and most of the tribe slept under palm-thatched huts. The hides of gators and game, along with elegant bird plumes, were brought to Fort Myers to be sold or traded.

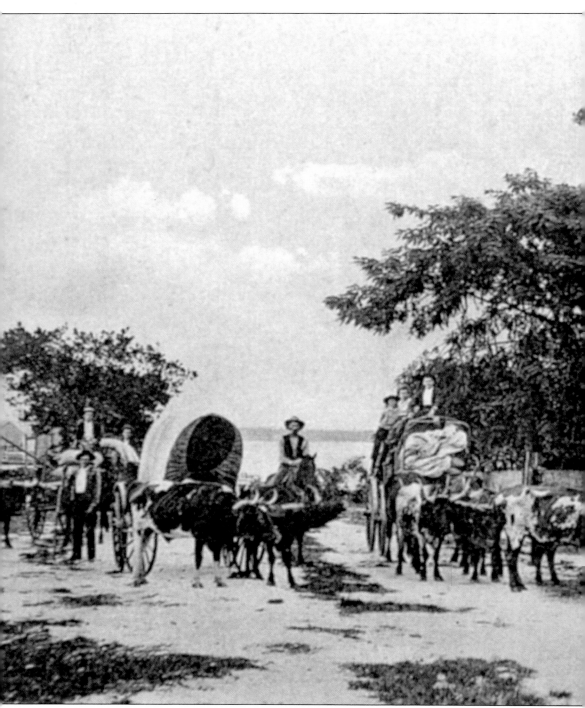

Many families in Lee County lived in the backcountry, where solitude and wildlife abounded. Supplies, though, had to be obtained in Fort Myers at general stores. Once provisions were secured, these hardy pioneers, with their high-wheeled wagons and obedient oxen, departed

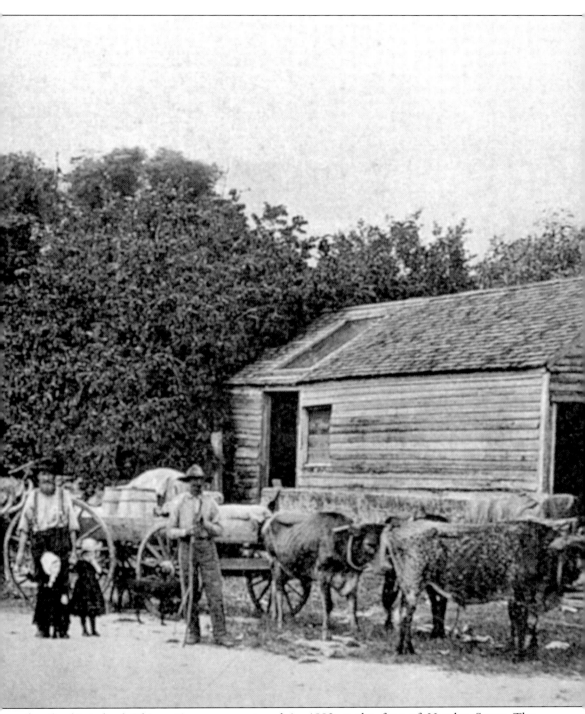

for the hinterland. This setting was composed in 1892 at the foot of Hendry Street. The famed Caloosahatchee River—artery to the outside world—lay in the distance. (Collection of Sara Nell Gran.)

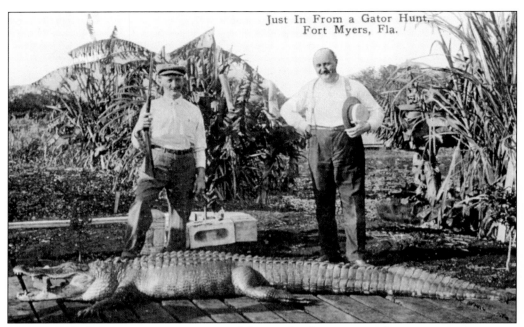

This scene, for better or worse, was repeated thousands of times. Gator hunting was once a great and unregulated sport. After the trophy photograph was snapped, the carcass was skinned, and parts of this ancient beast were cooked or preserved. (Collection of Sara Nell Gran.)

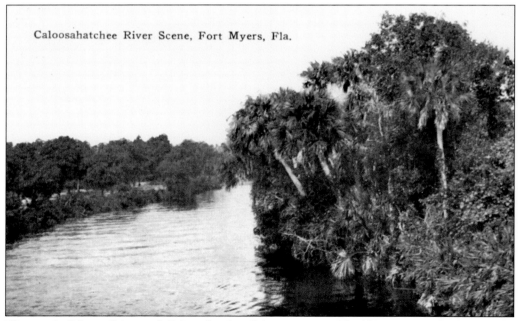

The words Caloosa River and Caloosahatchee River appear on Florida maps as early as 1760. For longer than man can remember, this artery of commerce and transportation has been linked to the history of Fort Myers. (Collection of Sara Nell Gran.)

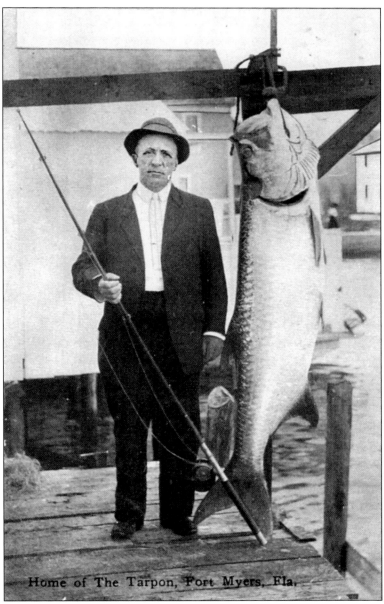

Home of The Tarpon, Fort Myers, Fla.

Many sportsmen regard the tarpon as the greatest game fish in the world. Two people are necessary for the thrilling sport—the fisherman himself and an able boat handler. At first, the feisty specimen was caught with a harpoon or a hook and chain. But in 1885, a New York sportsman successfully used a rod and reel. The hair-raising account was flashed around the country, and before long sportsmen and notables flocked to Punta Rassa, where today the causeway to Sanibel Island begins. Telegrapher George Shultz and wife hosted visitors at an old army barracks building. In 1885, Thomas Edison paid a visit. Other luminaries appeared, such as millionaire Ambrose McGregor, for whom today's McGregor Boulevard is named. Most took a side excursion up the Caloosahatchee and fell in love with Fort Myers. (Collection of Sara Nell Gran.)

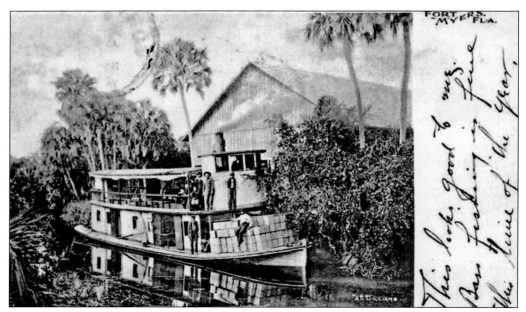

Messages on early American postcards had to be written on the front side. The sender of this 1900 example writes, "This looks good to me. Bass fishing is fine this time of year." The steamboat, whose bow teems with orange crates, is somewhere on the narrow reaches of the Caloosahatchee, east of Fort Myers. (Collection of Sara Nell Gran.)

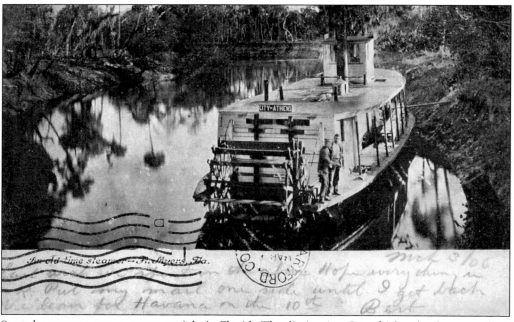

Steamboats were once a common sight in Florida. The diminutive *City of Athens* has her gangplank lowered in search of a passenger, or crates of citrus. The 1906 cancellation obscures the hand-written message, but the setting was definitely on the twisty Caloosahatchee. (Collection of Sara Nell Gran.)

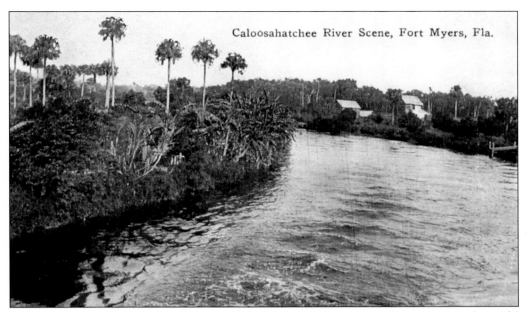

Caloosahatchee River Scene, Fort Myers, Fla.

The word Caloosahatchee roughly means "river of the Caloosa Indian." At one time, beautiful pineapple farms and orange groves, extending for miles, dotted its banks. (Collection of Sara Nell Gran.)

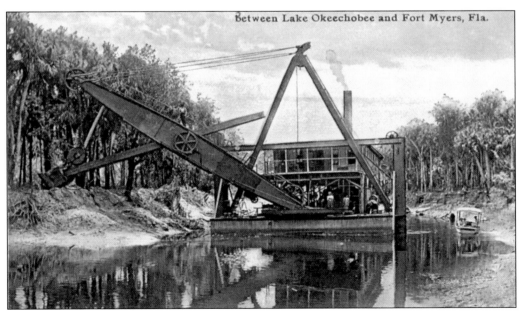

Between Lake Okeechobee and Fort Myers, Fla.

Navigational improvements to the Caloosahatchee were started in earnest in 1882. A route (with canals) between Lake Okeechobee and Fort Myers opened the following year. In 1909, Menge Brothers steamboats could make the run from Fort Myers to LaBelle in eight hours, with several intermediate stops.

This postcard, mailed in 1908, depicts a scene on the Orange River, which empties into the Caloosahatchee at East Fort Myers. The sandy soil and frost-free weather made citrus production easy. Growers depended on shallow-draft steamboats to take their harvests to the big packinghouse

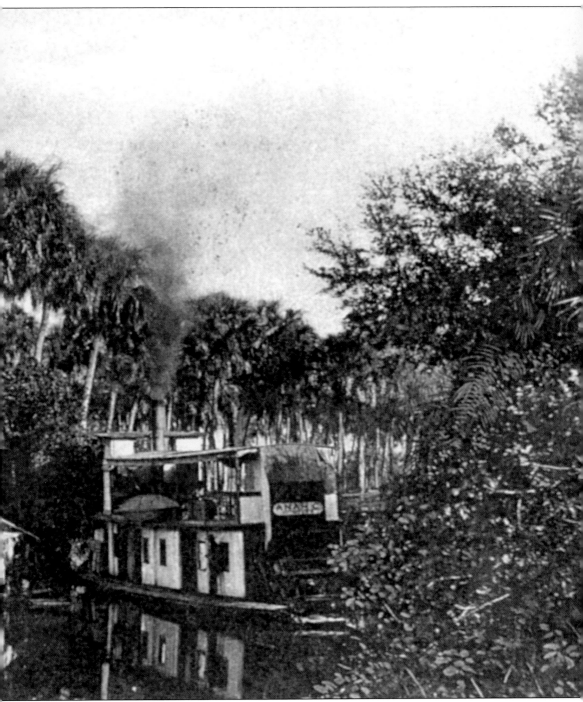

in Fort Myers. Here, the fruit was cleaned and sized. Then the loaded crates were placed aboard ventilated cars of the Atlantic Coast Line Railroad (ACL) for the trip north. Today, mostly pleasure craft ease up and down the Orange River. (Collection of Sara Nell Gran.)

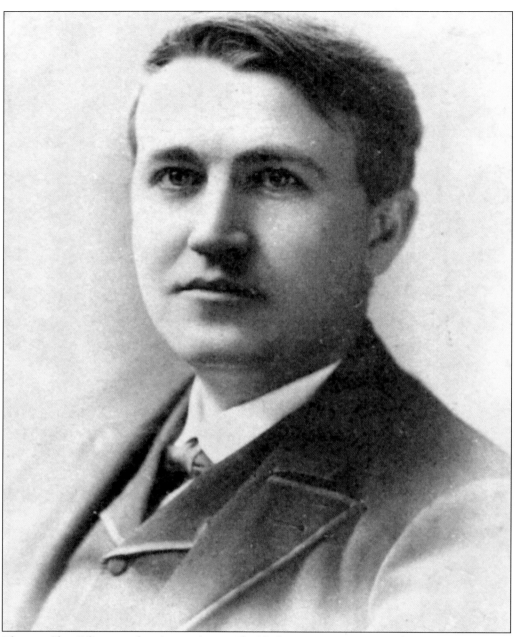

Thomas Alva Edison made winter trips to Florida beginning in 1882, perhaps earlier. Curious about tarpon fishing, he made his way to Punta Rassa in March 1885. George Schultz, a fellow telegrapher, played host. Shortly afterwards, Edison journeyed up the Caloosahatchee to see Fort Myers. The setting captivated the inventor, and thus began a 46-year relationship. The "Wizard of Menlo Park" acquired a riverside parcel for $2,750 and had a winter retreat built, as well as a laboratory. Edison returned to New Jersey, remarried the following February, and spent his honeymoon in Fort Myers. (Florida State Photo Archives.)

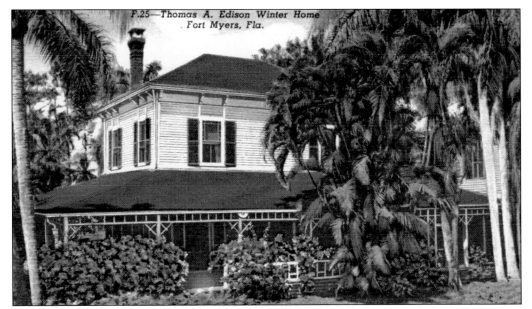

Edison's winter home in Fort Myers—named "Seminole Lodge"—was built on the south bank of the Caloosahatchee River. The two-story wooden structure was fabricated in Maine and brought to Florida by schooner. In time, the grounds boasted tropical flowers, gardens, and exotic trees. A lengthy dock jutted into the river.

Edison's experiments in Fort Myers were carried out inside this laboratory. Here, Mina and her inventive husband pose in front of the building that, in 1928, was moved to Henry Ford's Greenfield Village in Dearborn, Michigan. Obligations elsewhere absented the Edisons from Fort Myers between 1887 and 1901.

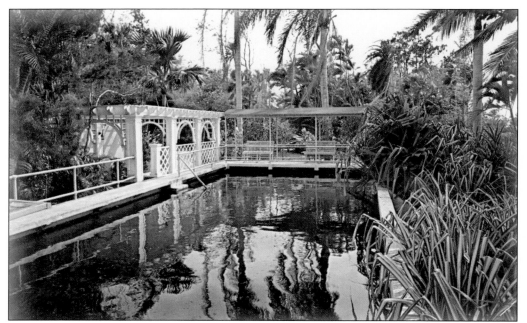

The Edison home in Fort Myers is one of the most visited historic sites in all of America. Visitors are frequently amazed to see a swimming pool at the setting. Edison had the concrete "bathing pool" built in 1910, the first residential example in Fort Myers. But Edison himself did not believe in exercise!

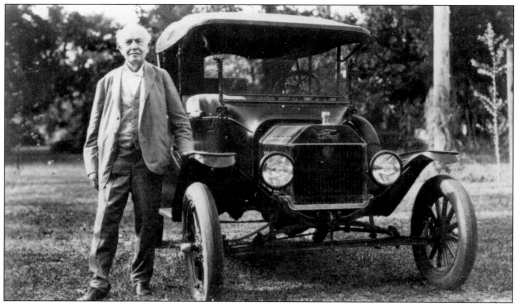

Henry Ford, a former employee of the Edison Illuminating Company in Detroit, regarded Edison as his mentor and friend. The auto-industrialist presented Edison with several cars, including this 1916 Model T. Edison garaged the gifts at Seminole Lodge in Fort Myers, where they can still be seen.

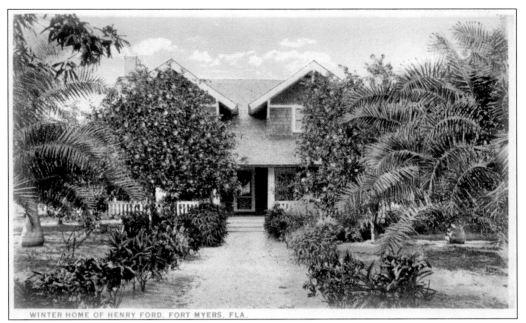

WINTER HOME OF HENRY FORD, FORT MYERS, FLA.

An unpretentious riverside home, next door to Seminole Lodge, went on the market in 1916. Its owner made Henry Ford aware of the fact, and Ford later purchased "The Mangoes" for $22,000. Clara and Henry Ford hardly entertained in Fort Myers, but rolling up the living room carpet and square dancing was a favorite pastime.

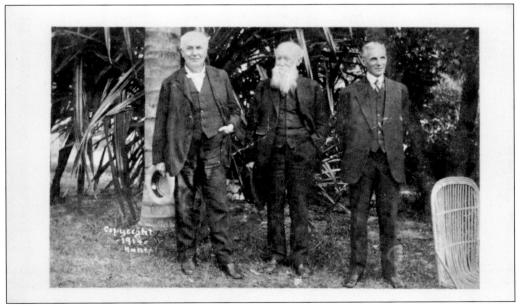

In this postcard, taken at Fort Myers, are Thomas Edison (left), Henry Ford (right), and the renowned naturalist John Burroughs. The trio, along with tire maker Harvey Firestone, often camped in the Florida backwoods. Ford introduced Burroughs to Edison in 1914.

Monroe County, Florida, was the largest county in America in 1887. The county seat was situated at Key West. That year legislators carved out Lee County from Monroe, and Fort Myers became the new county seat. Captain Francis Asbury Hendry— "Father of Fort Myers"—had it named for the Civil War general.

ROBERT E. LEE, by Cora Burghard
In the lobby of The Lee County Bank
Fort Myers, Florida

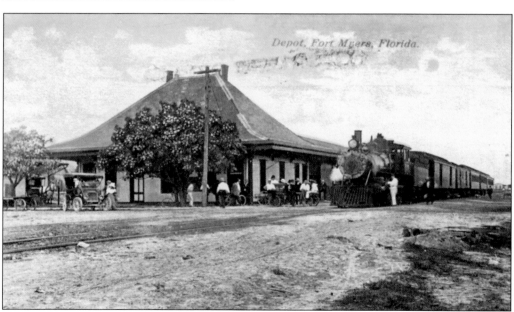

Depot, Fort Myers, Florida.

Fort Myers rejoiced when the Atlantic Coast Line Railroad arrived in 1904. The first station (seen here) was located on Monroe Street. Soon, tourists and newcomers started to arrive as never before. Citrus growers could now ship their fruit to northern markets in ventilated box cars. Vast quantities of fish—packed in ice—were also dispatched.

Two

GROWING UP

No stormy winter enters here,
'Tis joyous Spring throughout the year.
To those who know thee not, no words can paint;
And those who know thee, know all words are faint.
<div align="right">—Lee County brochure, Atlantic Coast Line Railroad, 1909</div>

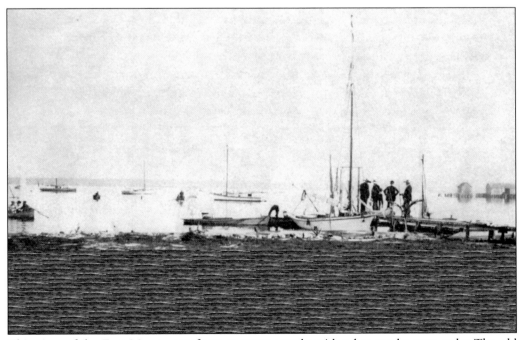

This view of the Fort Myers waterfront contrasts greatly with what can be seen today. The old cow town was slowly becoming civilized, though hogs and cattle still roamed through streets and yards in search of food. The wide and placid waters of the Caloosahatchee can be seen in the background. (Florida State Photo Archives.)

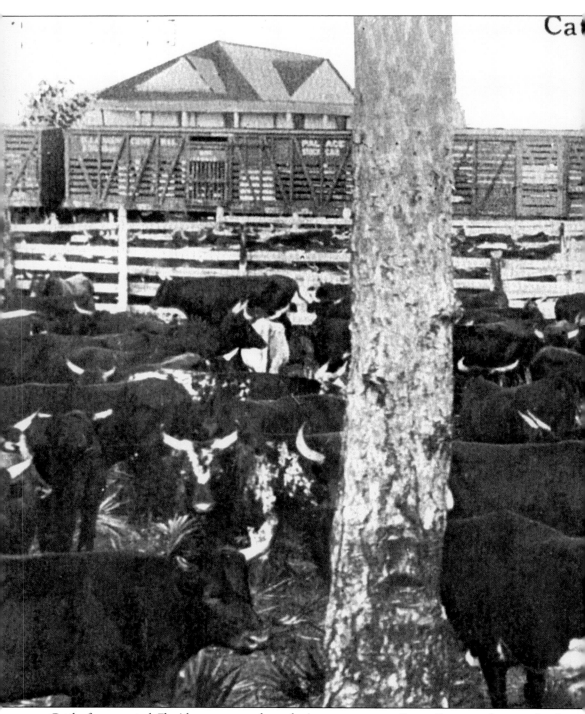

Cattle from central Florida were once brought in easy stages to Punta Rassa, at the mouth of the Caloosahatchee. Here, they were shipped to Key West and Cuba, and owners were paid in gold coin. When the ACL came to Fort Myers in 1904, the glory days of Punta Rassa as an

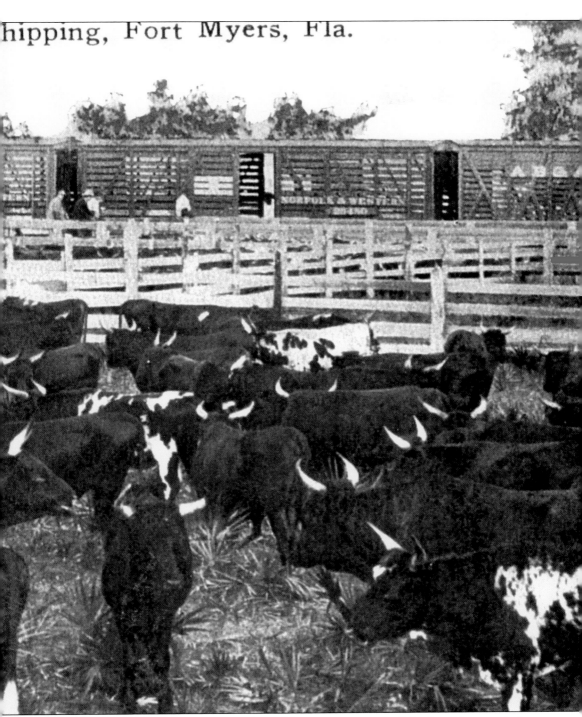

important cattle shipping point came to a close. Elaborate pens were built in Fort Myers, and after being fed and watered, the herds were cajoled into awaiting cattle cars for the trip to northern packinghouses. (Collection of Sara Nell Gran.)

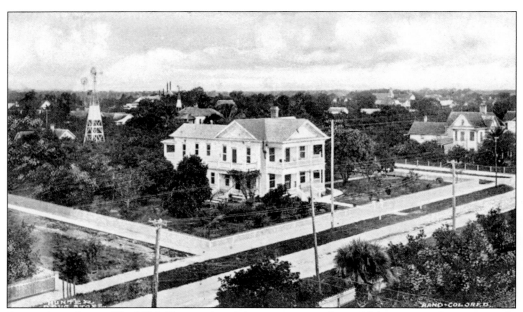

Postcard producers liked "bird's-eye views" because so much could be squeezed into a single picture. Photographers usually climbed to the city's highest roof in search of a vista. The Gwynne mansion dominates this 1910 scene. The windmills powered well pumps. At this moment, about 2,300 people resided in Fort Myers.

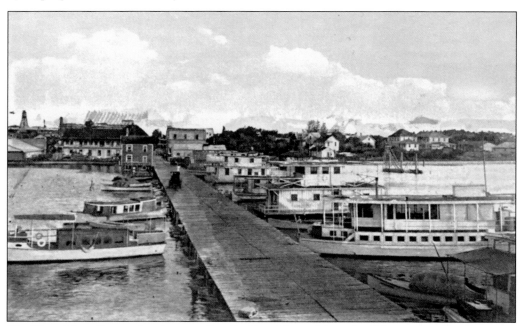

The "Iron Horse" proved to be a catalyst for Fort Myers. Not only did newcomers and tourists start to arrive, but also a new spirit of civic-mindedness arose. Better streets and sidewalks were built, new buildings arose, and derelict structures were demolished. The Ireland Dock (foot of Hendry Street) received attention as well.

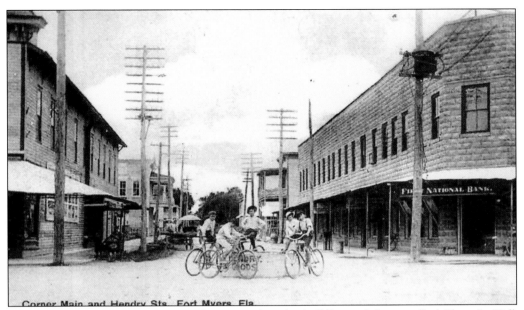

This view, taken in 1908, looks south on Hendry. The building at left was called Phoenix Hall. Across the street was the Stone Block, or the Leon Building. The bicyclists are resting against an old water trough for horses, which was removed two years later. No "honk-honks" can be seen.

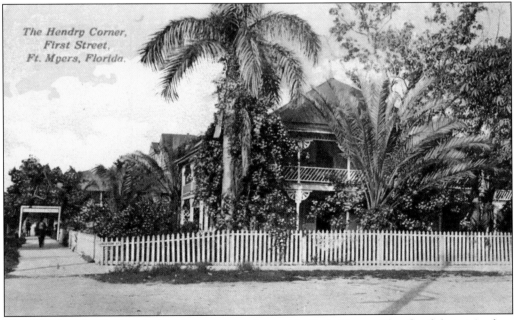

The Hendry family has had a long connection with Fort Myers. The family's patriarch—Captain Francis Asbury Hendry—served in the Confederate "Cattle Guard," the battalion that attacked Fort Myers during the Civil War. After the hostilities, the wealthy cattleman eventually moved and became the "Father of Fort Myers."

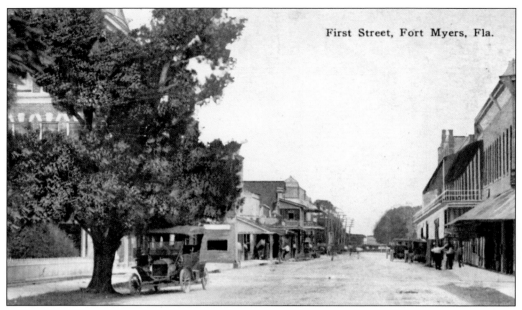

First Street, Fort Myers, Fla.

The first motorcar to enter Fort Myers did so on April 11, 1904. Back then, streets were paved with crushed shells, as this scene attests. In the distance, an ACL train eases across First Street en route to a dock on the Caloosahatchee. The Bank of Fort Myers looms through the tree at left.

Main St. Corner Jackson, Fort Myers, Fla.

Utility poles march down Main Street. It, too, was surfaced with crushed shell. Palms and oak trees can be seen, as well as something new—sidewalks! This 1915 postcard was printed in Germany, whose printing processes were world renowned.

Almost every Florida community has some relic from the past. The "Ye Old Wishing Well" was located in Fort Myers at Tropical Gardens, on Gladiolus Drive. This elderly view was colorized, a precursor to the color photograph.

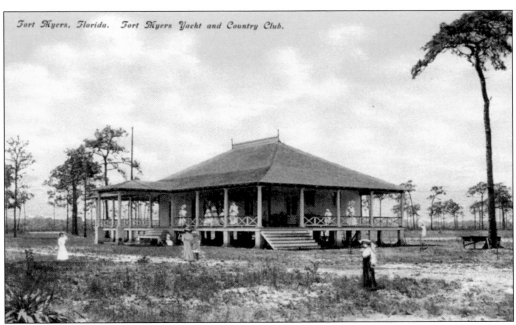

Tootie McGregor Terry donated a 40-acre tract to the Fort Myers Yacht and Country Club. Memberships were sold, a $2,500 clubhouse was begun, and golf links were planned. The East Fort Myers facility opened—uncompleted! —on February 21, 1908. But accessing the club via sandy roads proved tortuous, and the social enclave failed.

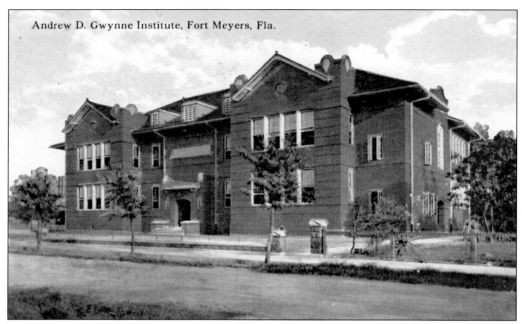

Andrew D. Gwynne Institute, Fort Meyers, Fla.

As Fort Myers grew, so did its school population. But the schoolhouse at Jackson and Second proved inadequate, which disturbed Col. Andrew Gwynne, a wealthy Tennessee cotton broker and winter visitor. He died in 1909, and his estate left a substantial gift towards a new facility. Additional funds were raised, and in 1911, the $45,000 Gwynne Institute opened its doors.

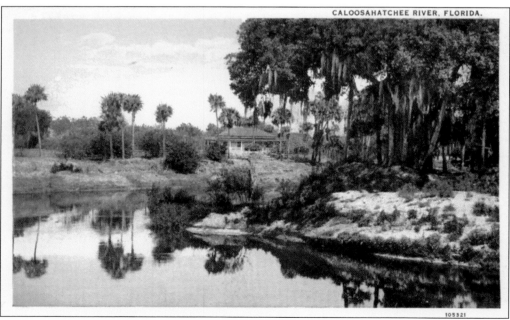

CALOOSAHATCHEE RIVER, FLORIDA.

Numerous postcards depict the twisty Caloosahatchee east of Fort Myers. Steamboat captains had to keep a steady eye on what lay ahead, for the river's channel frequently shifted, silted, or angled around sharp bends, as this colorized scene attests.

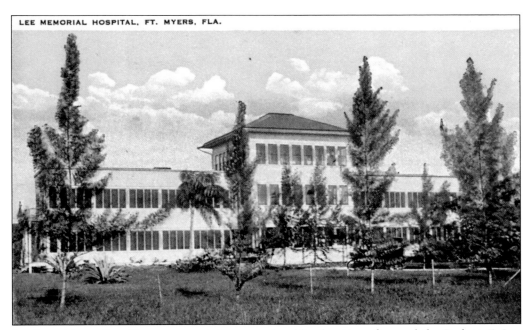

Leading citizens, Lee County commissioners, and public donations financed the Robert E. Lee Hospital. It opened in 1916 and stood at Victoria and Grand Avenues. A new $200,000 hospital arose in 1943 on Cleveland Avenue, financed by the Works Progress Administration (WPA). Since then, Lee Memorial Hospital has undergone numerous expansions.

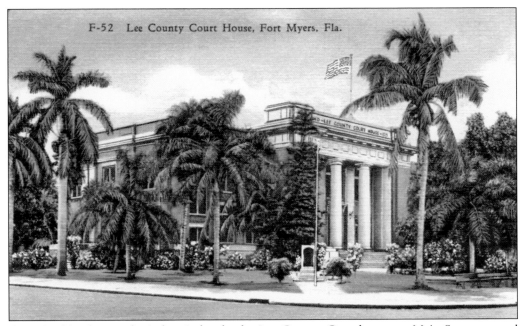

Conceived in the neoclassical revival style, the Lee County Courthouse on Main Street opened in 1915. It was built of yellow brick and cost $100,000. The building quickly made its way onto postcards. Lumber from the first courthouse was used in creating the Robert E. Lee Hospital.

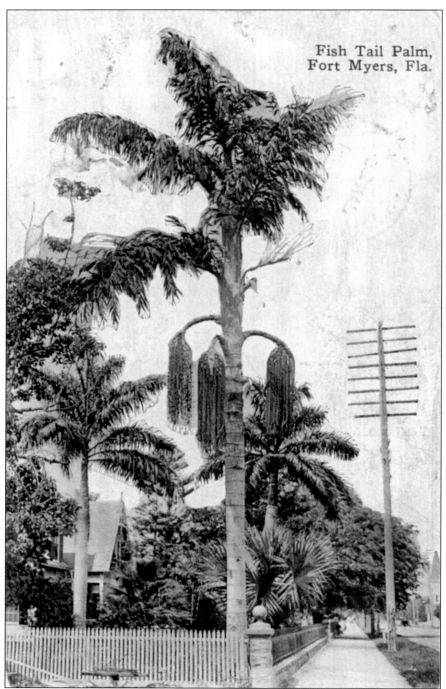

Fish Tail Palm,
Fort Myers, Fla.

Because of the tropical climate, palm trees flourish in Fort Myers. There are numerous species, and eventually Fort Myers came to be known as "The City of Palms." The majestic royal palm beautifies many city streets, especially McGregor Boulevard. But for uniqueness, the fish tail palm is hard to beat. (Collection of Sara Nell Gran.)

Three

SOME NOTABLE HOMES
AND HOTELS

Fort Myers is the Italy of America and the only true sanitarium of the Occidental hemisphere, equaling if not surpassing the Bay of Naples in grandeur of view and health giving properties.
—*Fort Myers Press*, 1885

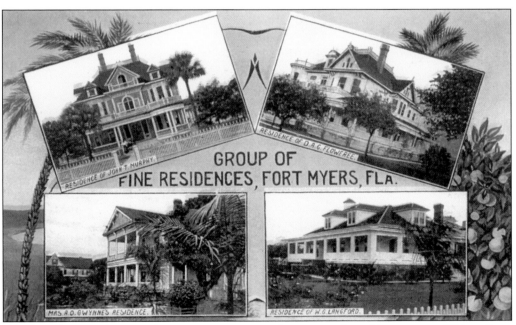

As men of means discovered Fort Myers, more and more stately residences arose. This collage, issued by Hunters Drug Store, captures four such homes against a background of orange and palm trees. The home of cotton broker Andrew Gwynne, whose estate helped make possible the Gwynne Institute, is pictured in the lower left. (Collection of Sara Nell Gran.)

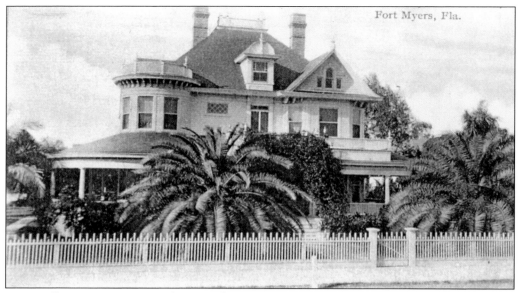

Capt. William F. Gwynne was the son of cotton broker Andrew Gwynne. William's home, near First and Fowler, had first been built for Montana cattleman Daniel Floweree in 1901 for $20,000. Floweree himself had come to the region largely for tarpon fishing. (Collection of Sara Nell Gran.)

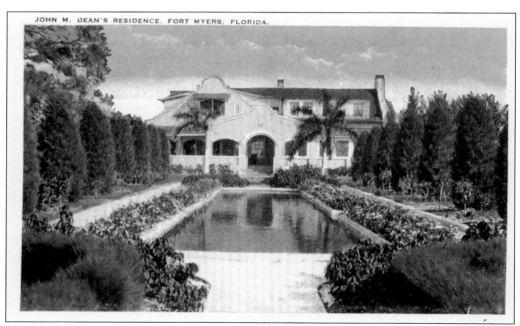

Furniture merchant John Dean started coming to Fort Myers to hunt in 1898, by way of Providence, Rhode Island. Two years later, he invested in citrus groves, then developed what became Dean Park. Other subdivisions followed. His pride and joy was the Morgan Hotel. (Collection of Sara Nell Gran.)

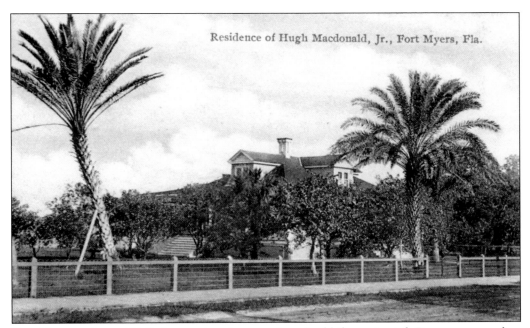

Residence of Hugh Macdonald, Jr., Fort Myers, Fla.

Fort Myers stationer J.B. Parker produced postcards and sold them at retail. Dozens appeared, as collectors of today can confirm. The homes of prominent residents were popular sellers, including this one that belonged to Hugh Macdonald Jr.

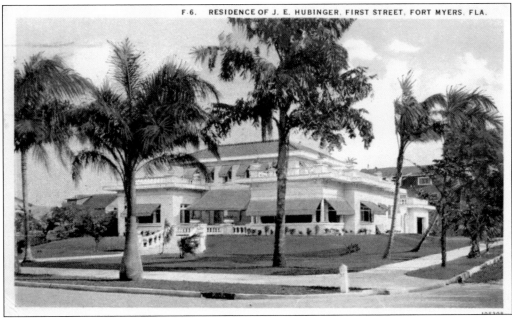

F.6. RESIDENCE OF J. E. HUBINGER, FIRST STREET, FORT MYERS, FLA.

Although the Hubinger family once resided here, this splendid First Street residence had actually been built for Clarence Chadwick, who invented forgery-proof paper for bank checks. Completed in 1925, it featured one-foot-thick walls of concrete. Today this embankment home houses a legal firm.

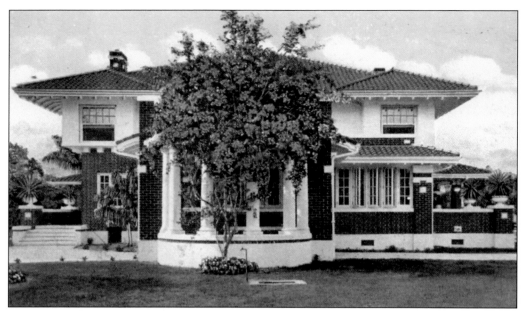

Fort Myers businessman Walter Langford built this home in 1919, based on one he saw in Jacksonville. Constructed of red brick and white masonry trim, the house had two hip dormers and Spanish roof tile. Langford died the next year, George Kingston purchased it in 1925, and in 1953 the nearby Methodist Church acquired it. Recently it was moved.

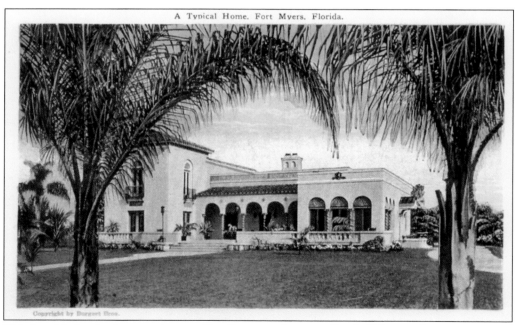

This Spanish-inspired masterpiece on First Street was home to Frank Alderman Sr. It was pictured in the 1926 book, *The Spanish House for America,* by Rexford Newcomb. Arched windows, volume ceilings, and Spanish tile abound. Alderman was a successful attorney, banker, and businessman. (Collection of Sara Nell Gran.)

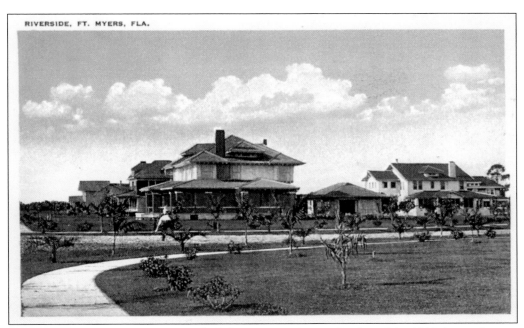

Riverside Avenue in Fort Myers, which became McGregor Boulevard in 1912, boasted many superb homes. This scene appeared on a one-cent postcard issued by the Fort Myers Bookstore. All the homes pictured had frontage on the Caloosahatchee River, which at this point is nearly one and a half miles wide. (Collection of Sara Nell Gran.)

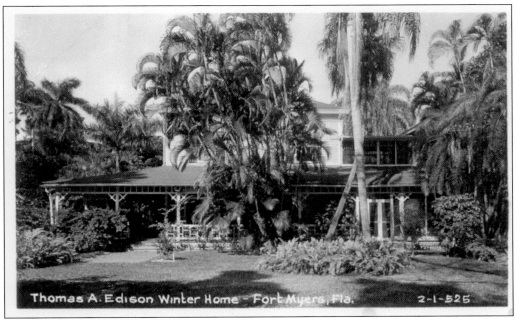

Thomas A. Edison Winter Home - Fort Myers, Fla. 2-1-525

Dozens of postcards exist of Edison's Seminole Lodge. Different views of the exterior, the rooms therein, the grounds, etc., have appeared, but for clarity of detail, none could surpass those that utilized a crisp black-and-white photograph. (Collection of Sara Nell Gran.)

39

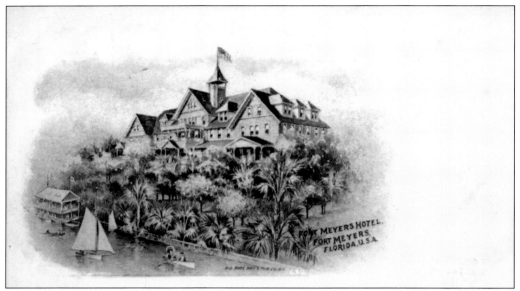

For years, Fort Myers lacked a five-star hotel. That is until New York department store merchant Hugh O'Neill heeded the call. O'Neill tore down the Hendry House and put up the four-story Fort Myers Hotel, which opened in style on January 15, 1898. After planting royal palms, O'Neill renamed it the Royal Palm Hotel.

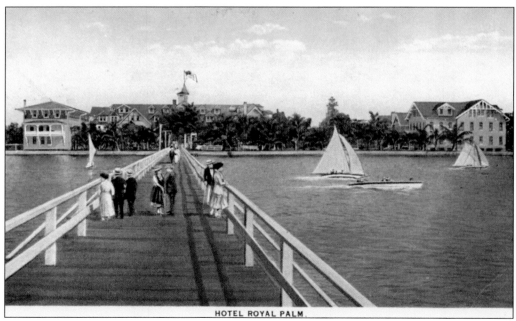

HOTEL ROYAL PALM.

Tampa architects Miller & Kennard designed O'Neill's hostelry. It offered 135 cozy rooms, and was the first commercial structure in Fort Myers wired for electricity. A 600-foot pier jutted into the river; yachts and pleasure craft came and went. O'Neill, no stranger to Madison Avenue, advertised its charms far and wide.

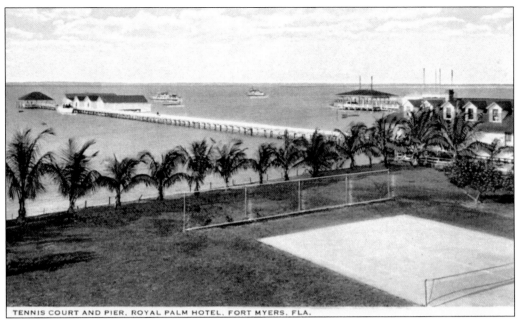

TENNIS COURT AND PIER, ROYAL PALM HOTEL, FORT MYERS, FLA.

No amenity was overlooked at the Royal Palm, including clay tennis courts. River breezes kept players comfortable. The editor of the *Louisville Courier-Journal* in Kentucky called the place, "the most charming hotel of its kind in the world. I know nothing so beautiful and attractive in Florida or southern Europe."

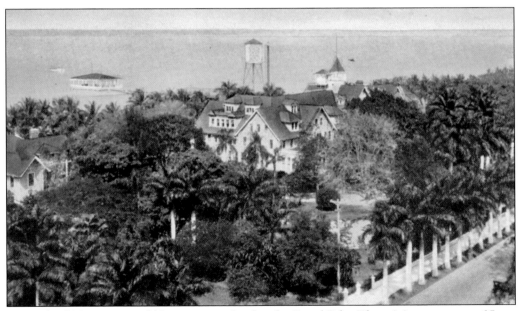

Upwards of 200 guests could be accommodated at the Royal Palm. The minimum rate was $5 per day. The hotel was the epicenter of Fort Myers, as the wonderful 1950 book *Open for the Season* relates. Author Karl Abbott notes: "The hotel catered to a splendid clientele. A number of yachts lay in the harbor, life was carefree."

41

This image of the Royal Palm was taken in 1930 by Burgert Brothers, the famed photographic house in Tampa. The royal palms that O'Neill brought in from Cuba have reached maturity. In the right distance is the long, Seaboard Air Line Railway bridge. In fact, when that line to Fort Myers was opened on January 7, 1927, a welcoming reception was hosted at the hotel. When the hostelry

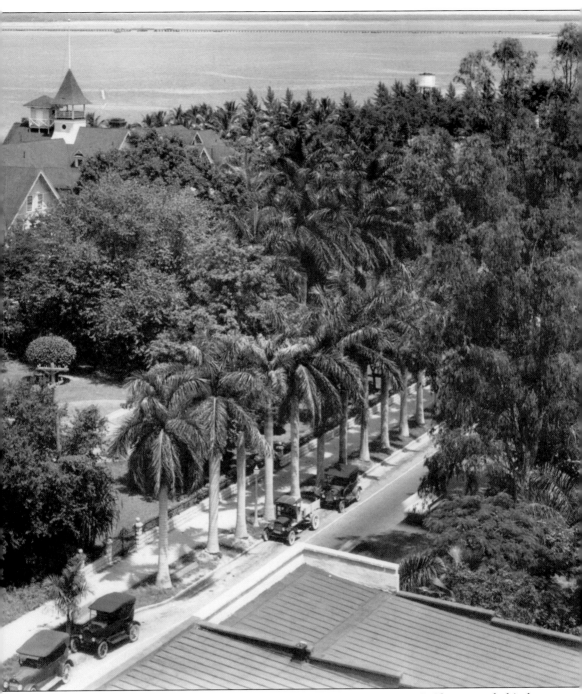

first opened in 1898, it was revealed that Florida developer-magnate Henry B. Plant was a behind-the-scenes investor. Ownership changes occurred after O'Neill's death in 1902. The hotel became a World War II barracks and was razed in 1948. What a place!

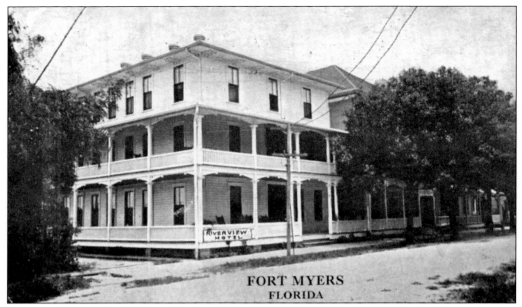

FORT MYERS
FLORIDA

The Riverview Hotel began life, near the Caloosahatchee, in 1883 as the Keystone Hotel. Thomas Edison spent part of his honeymoon here, calling it a "flea trap." Later it became known as the Fort Myers Inn, then the Caloosa House. In 1895, the structure was moved to the center of town, enlarged, and renamed the Riverview. New management got rid of the fleas.

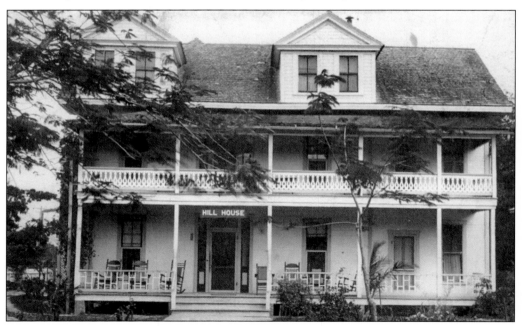

Mary Hill had this hostelry built at First and Lee in 1889. Her daughter, Flossie, helped run the boardinghouse. Meals were cooked on a 900-pound cast-iron stove. The rate was $2.50 a day. Flossie had ambitions, and later she opened a popular woman's clothing store on Jackson Street. (Collection of Sara Nell Gran.)

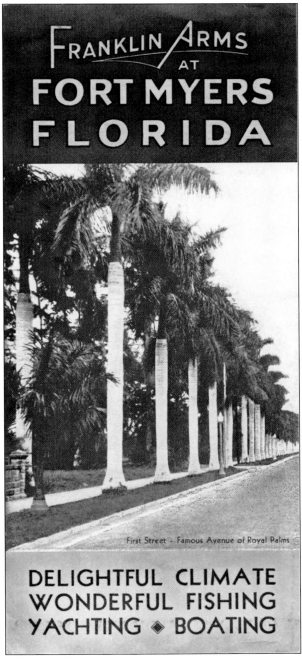

FRANKLIN ARMS
AT
FORT MYERS
FLORIDA

First Street - Famous Avenue of Royal Palms

DELIGHTFUL CLIMATE
WONDERFUL FISHING
YACHTING ◆ BOATING

The Franklin Arms was operated as a resort and had a reputation for Southern hospitality. All rooms overlooked the Caloosahatchee or the palm–dotted residential and business section of Fort Myers. In 1924, a seven–story addition was added, making the 102–room facility the city's first "skyscraper." During the crazy land boom years of the 1920s, a "human fly" ascended the hotel's exterior. He stopped at each floor and told folks to buy land in a new Fort Myers subdivision—Palmlee Park.

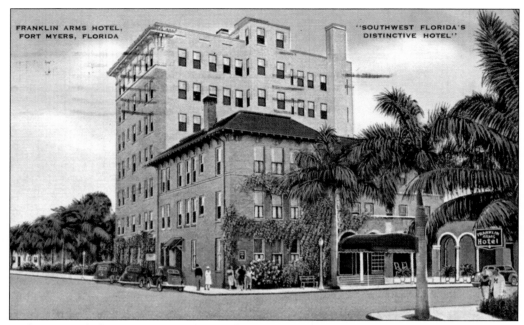

In this postcard, the seven-story addition of 1924 dwarfs the original Franklin Arms Hotel. It was located opposite the "open-air" post office in Fort Myers (completed in 1933). A facelift occurred in recent years, and the building became known as the Edison Regency House.

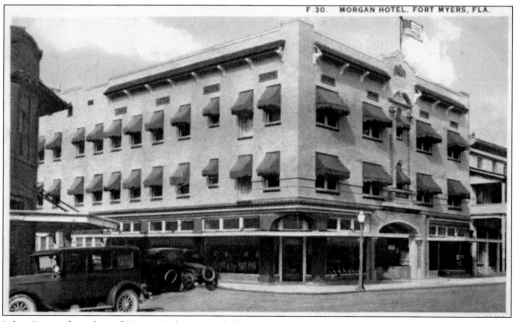

John Dean, founder of Dean Park, opened the Morgan Hotel in 1924. It had 22 rooms, and the main entrance fronted First Street. A 70-room addition was added the following year. A few decades ago, the popular hostelry was renamed the Dean Hotel.

Bradford Hotel patrons, especially sportsmen, regarded their refuge as one of the finest in the South. It had its own Gun Club, and practice shoots were held daily at nearby traps. The hotel had 80 rooms and was operated on the "American Plan," which offered three meals a day, versus the "European Plan's" breakfast and dinner. Harvie Heitman built the 1905 structure with financial help from Tootie McGregor Terry.

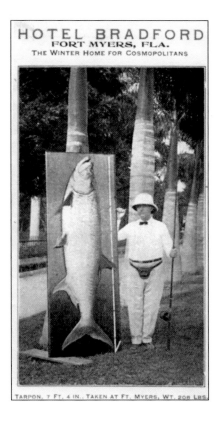

HOTEL BRADFORD
FORT MYERS, FLA.
THE WINTER HOME FOR COSMOPOLITANS

TARPON, 7 FT. 4 IN., TAKEN AT FT. MYERS, WT. 208 LBS.

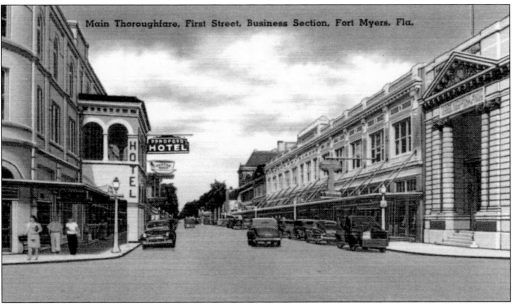

Main Thoroughfare, First Street, Business Section, Fort Myers, Fla.

First Street was once a shopping mecca in Fort Myers. The age of the automobile is firmly entrenched, as this postcard confirms.

Here is a souvenir folder of Fort Myers dating from the 1920s.

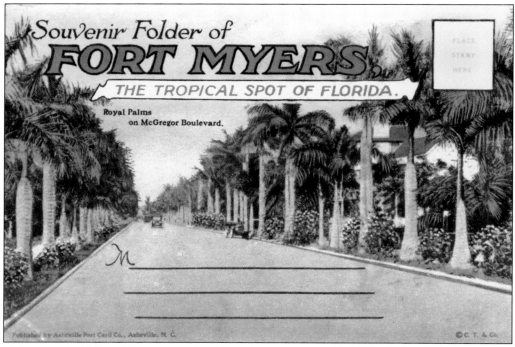

This souvenir folder of Fort Myers dates from the 1930s.

Four

PROSPERITY TO WAR

The character of Fort Myers justly entitles it to the appellation The Garden Spot of Florida, it being more beautiful and attractive than any ever seen in southern Europe. I am in love with it because it is a Garden of Eden. . . because it is a Rivera without swells. One may travel the United States over and over and not find a more equable climate than in Lee County.
—Col. Henry Watterson, editor, *Louisville-Courier Journal*, 1910

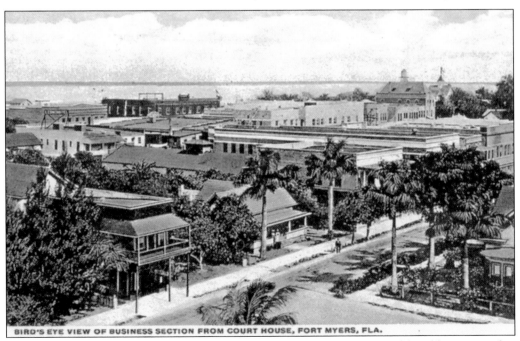

BIRD'S EYE VIEW OF BUSINESS SECTION FROM COURT HOUSE, FORT MYERS, FLA.

This bird's-eye view was composed around 1920. Practically every vestige of the old cow town has vanished, including derelict wooden buildings. The three-story Bank of Fort Myers building, with hip roof, erected in 1911, can be seen in the distant upper right. The photographer snapped this scene from the roof of the courthouse.

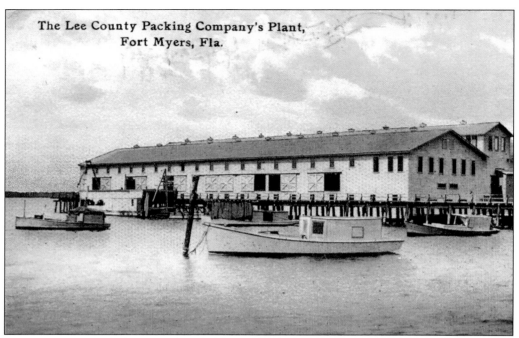

The Lee County Packing Company's Plant,
Fort Myers, Fla.

Harvie Heitman and John Dean founded the Lee County Packing Company. A substantial building was constructed in 1910 that stood on piers in the Caloosahatchee. Steamboats dropped off fruits and vegetables from area growers; ACL trains carried off the crates. Twenty cars of fruit could be packed in a single day.

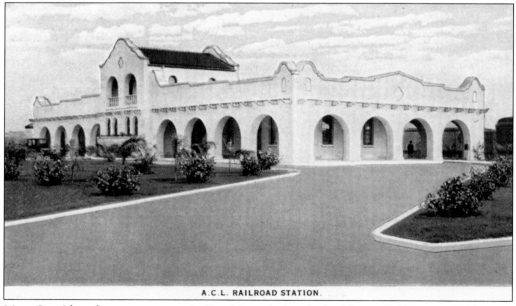

A.C.L. RAILROAD STATION.

Many Spanish-style structures arose in Fort Myers during the land boom. In February 1924, a new station was opened by the ACL on Peck Street that cost $48,000. Today it houses the Southwest Florida Museum of History.

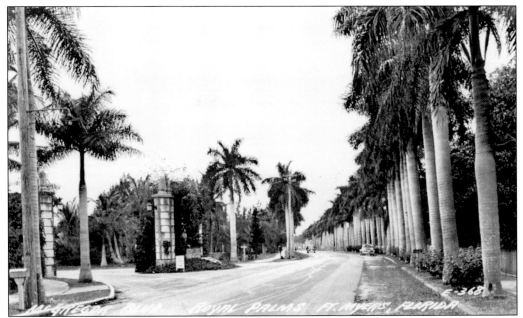

In 1907, Thomas Edison offered to install royal palms along Riverside Drive. (Riverside became McGregor Boulevard in 1912.) Discussions followed, town fathers accepted, and hundreds were planted. This is McGregor Boulevard in 1933, near the Edison home. The entrance to Edison Park, a real-estate subdivision, is at left. (Collection of Sara Nell Gran.)

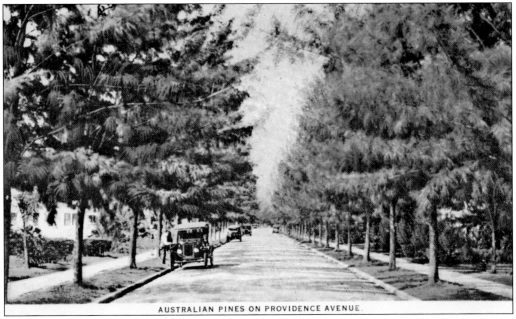

AUSTRALIAN PINES ON PROVIDENCE AVENUE.

Another tree species that flourishes in Fort Myers is the Australian pine, whose long and slender needles fascinate tourists and visitors. This 1920s scene was composed on Providence Street, in Dean Park, where the trees were planted in abundance.

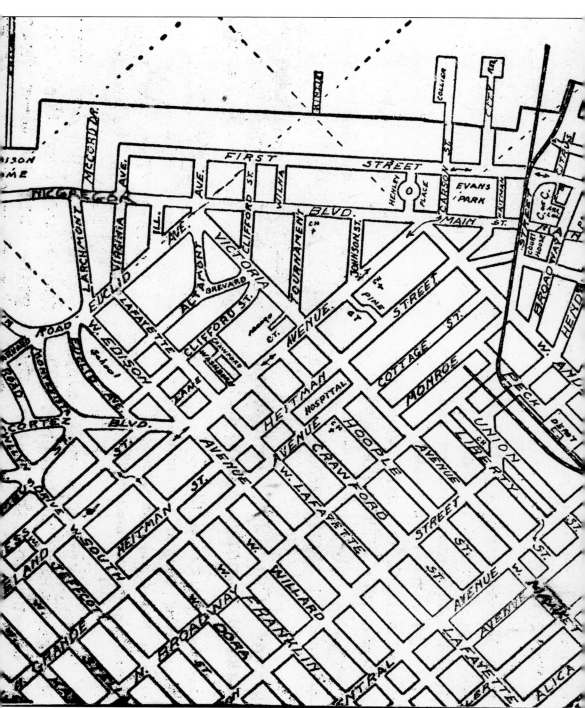

This map of downtown Fort Myers dates from 1940. The track of the ACL comes in from the northeast and heads for the station on Peck Street, then down to the docks. The Seaboard Air Line Railway crosses the ACL track near the east end of Mango Street, then departs eastward to LaBelle

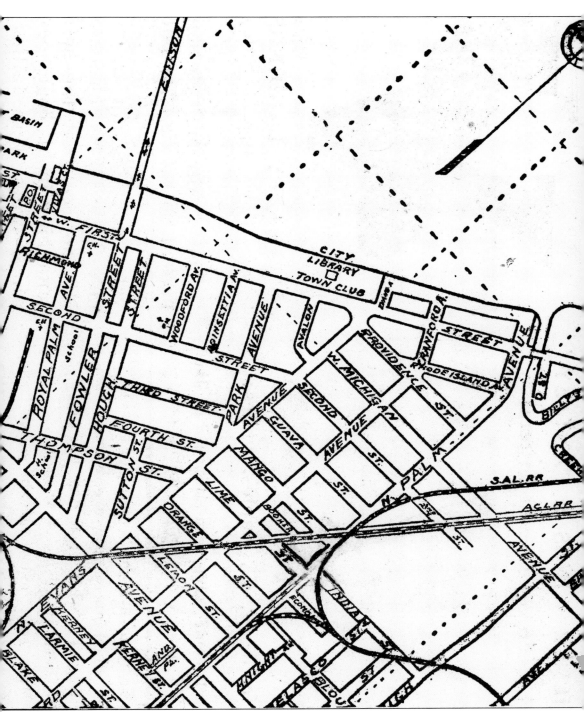

and southwards to Bonita and Naples. The famous yacht basin, a city treasure, opened in 1939. To its left was Recreation Pier. The Collier Line terminal and dock was located beyond the pier. The winter home of Thomas Edison is in the upper left, together with that setting's lengthy dock.

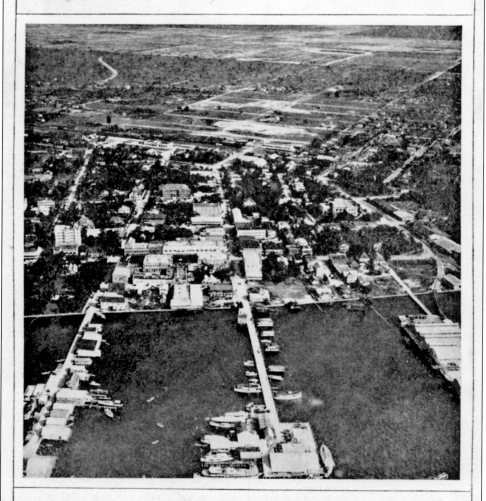

FORT MYERS

LEE COUNTY • FLORIDA

✦ THE CITY OF PALMS ✦

During the land boom of the 1920s, nurseryman James E. Hendry Jr. suggested to city fathers that Fort Myers be nicknamed "The City of Palms." The sobriquet struck a note, and before long the appellation appeared on anything relating to Fort Myers, as this 1926 brochure, by the Fort Myers Chamber of Commerce, confirms. Other popular slogans considered were "Fort Myers—Gateway to the Tropics" and "Fort Myers—Where Natures Work Is Finished."

FORT MYERS FACTS AND FIGURES

Most Northern Tropical City.

Population 9498.

Situated sixteen miles from the Gulf of Mexico, on the Caloosahatchee River. (Deep waterway and port facilities imminent.)

Assessed value of city property $30,-537,060.00.

Commission form of government.

$300,000 Amusement Centre (Proposed)

$100,000 Atlantic Coast Line Station.

$100,000 Court House.

Bank deposit increase 1924-1925 160%.

Municipal gas plant.

Third largest ice plant in the State.

Southern Utilities electric light plant.

Moving picture airdome (900 seats).

Three moving picture houses.

Municipal water works—Fire department.

Artesian water supply.

Modern telephone equipment.

Public parks—Library—Seven Churches.

Spring Training Grounds, "Athletics."

Paved streets—7½ miles.

17-mile Boulevard.

18-hole Golf Course—Country Club.

Robert E. Lee Memorial Hospital.

Two commercial piers.

One municipal pleasure pier.

22 miles double cement sidewalks.

4 Grammar, 1 High School, accredited, and 2 Private Schools.

One National Bank.

Two Trust Companies.

Three Clubs.

Thirty-one civic organizations.

Four tennis courts—one roque court.

One morning and one evening newspaper (Associated Press service).

Three exclusive job printing offices.

Western Union Telegraph.

Twelve furnished apartment buildings.

275 European plan rooms.

254 American plan rooms.

80 rooms (no dining room attached).

Five high grade boarding houses.

Second largest lumber mill in the State.

Modern ice cream plant.

Free band concerts daily.

Ten garages and filling stations.

Three modern laundries.

Three cigar factories.

Ten-story Skyscraper Office Building.

Automobile Bus Lines—three inter-urban, 3 local — territory within 100 miles each direction served.

Daily boat service to Gulf Islands.

Tri-weekly service to Tampa.

Weekly service to Everglades.

Home of the Tarpon Club.

Highest summer temperature 5 years—95 degrees.

One Weekly Publication.

Most equable climate in America. Cooler day for day in summer than Pennsylvania, Georgia, Ohio, Indiana, Illinois, Michigan, Minnesota, Iowa, Missouri, North Dakota, Nebraska, Kansas, Kentucky, Tennessee, Alabama, Mississippi, Louisiana, Texas, Oklahoma, Arkansas, Montana, Wyoming, Colorado, New Mexico, Arizona, Utah, Nevada, Idaho, Washington, Oregon and California.

In 1924 only four days U. S. Weather Bureau reporting wind less than three miles per hour. Swept by trade winds.

Midway between Tampa and Miami on Tamiami Trail. Fort Myers is the converging point of three state highways—all under Federal 7% system. Two lateral cross state roads converge here also.

Nine-hour train service from Jacksonville. Two fast trains from Tampa daily. Through Pullmans from New York and Chicago.

Active Realty Board, Kiwanis Club and Rotary Club. Virile, progressive Chamber of Commerce.

Fort Myers Beach, 8 miles White Sand.

New $150,000 Post Office.

Twelve office buildings.

Fastest growing city in America.

Spanish and Moorish type bungalows and residences.

This fact sheet helped comprise the brochure cited in the previous image. Accessing Fort Myers was easy in the Roaring Twenties. In 1927, for example, four passenger trains a day—several had Pullman sleepers and a diner—either departed or arrived at the City of Palms via the ACL, while another pair was operated by competitor Seaboard Air Line Railway.

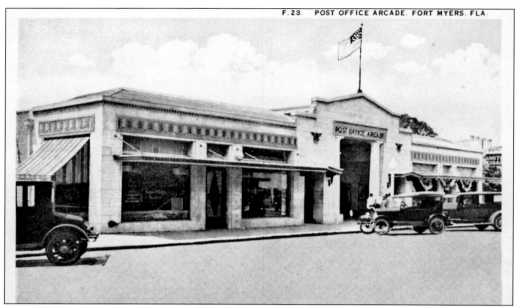

The Arcade Building on Broadway housed the second post office in Fort Myers. The building went up in 1925 for a cost of $100,000. It was owned by George Sims. Many other structures were built during the land boom, an age still remembered for flapper girls, jazz, bootlegged liquor, flashy cars, and radio.

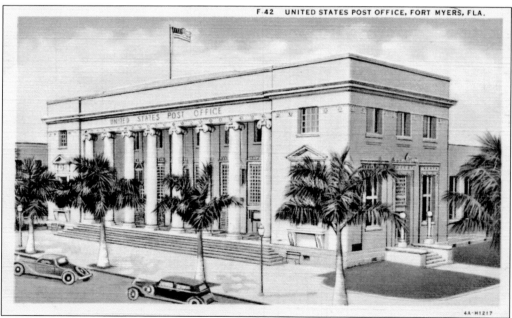

An open-air post office, which allowed patrons to access boxes without going inside, opened in Fort Myers on October 30, 1933. The $200,000 edifice was constructed of concrete, steel, and coquina rock quarried in the Florida Keys. In 1965, the post office moved to its present site. The facility seen above then became the Federal Building.

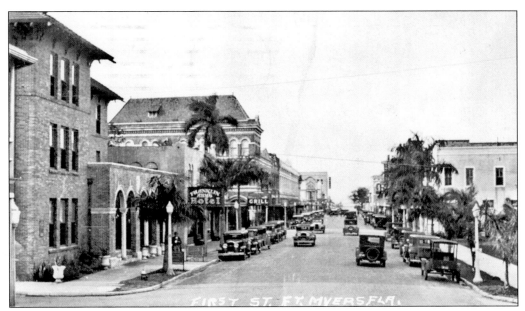

The land boom years were kind to Fort Myers. This postcard depicts First Street, looking west. The Franklin Arms Hotel is in the left foreground, followed by the hip-roofed Bank of Fort Myers on the corner of Jackson. Vintage motorcars line both sides of the commercial thoroughfare. (Collection of Sara Nell Gran.)

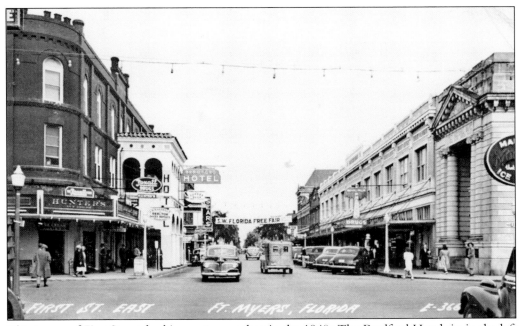

This image of First Street, looking east, was taken in the 1940s. The Bradford Hotel sits in the left foreground, and the local Sears outlet lay beyond, in the Heitman Building. The First National Bank, built in 1914, is in the right foreground at the corner of Hendry. The Bank of Fort Myers is further down the street. (Collection of Sara Nell Gran.)

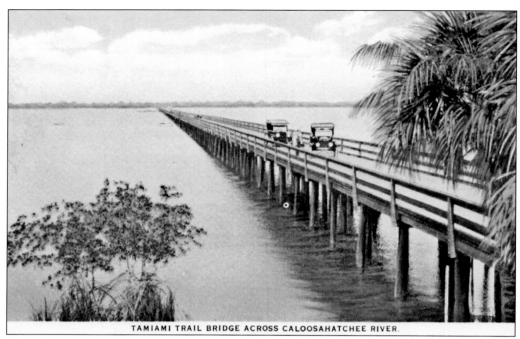

TAMIAMI TRAIL BRIDGE ACROSS CALOOSAHATCHEE RIVER.

Fort Myers was 150 miles south of Tampa. The famed Tamiami Trail, from Tampa to Miami, entered Fort Myers via a long $110,000 wooden bridge over the Caloosahatchee at Fremont Street. It opened in 1924, just as the land boom was reaching its peak. Four years later, the two-lane highway, begun in 1915, was completed to Miami.

Exploring nearby cities and towns was a popular diversion for early car owners, especially on Sundays. The purchase of a postcard (like this) confirmed area jaunts. (Collection of Sara Nell Gran.)

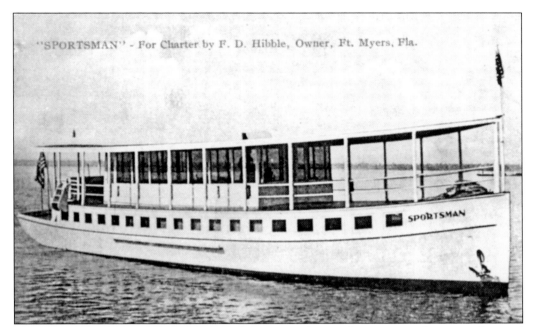

"SPORTSMAN" - For Charter by F. D. Hibble, Owner, Ft. Myers, Fla.

Fort Myers was noted for its unexcelled fishing, and frequently tourists and visitors chartered fishing boats. The *Sportsman* tied up in Fort Myers, attracted an upscale crowd, and took anglers out into the Caloosahatchee or the Gulf of Mexico. (Collection of Sara Nell Gran.)

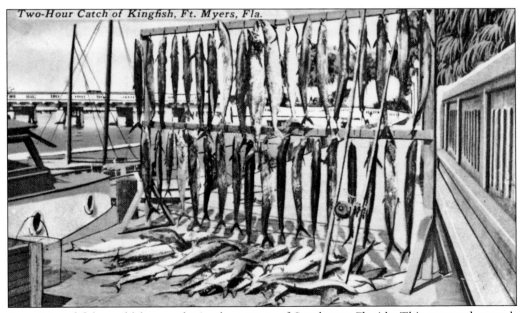

Two-Hour Catch of Kingfish, Ft. Myers, Fla.

A variety of fish could be caught in the waters of Southwest Florida. This postcard records a two-hour catch for kingfish. Tarpon was another sought-after variety, as well as sea trout, grouper, flounder, snapper, channel bass, Spanish mackerel, bluefish, flounder, sheepshead, shark, and jewfish.

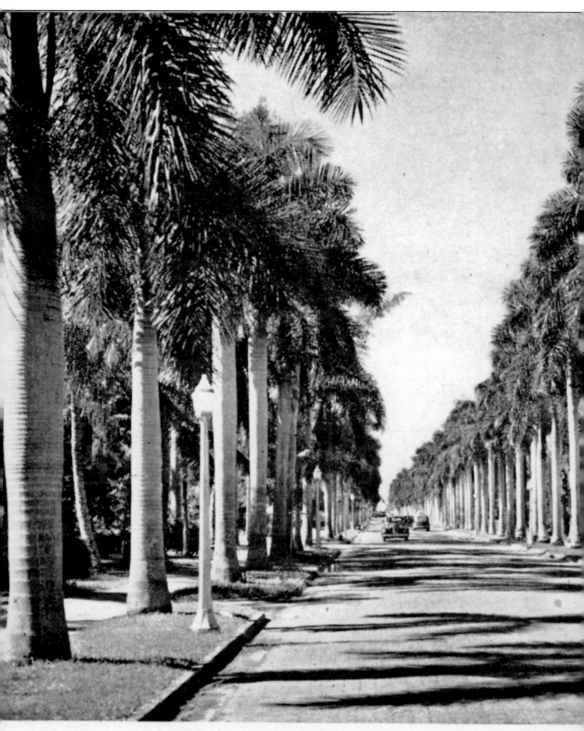

First Street is beautiful av

f palms

Royal palm trees march down First Street, as this 1930s postcard illustrates. For decades, "Millionaires Row" has been an important city thoroughfare. It was first surfaced with asphalt, and later with brick pavers, which are visible in this image, as are quaint streetlamps. For many years this was the major artery in and out of Fort Myers proper. Upon seeing it, many tourists and newcomers immediately fell in love with the city.

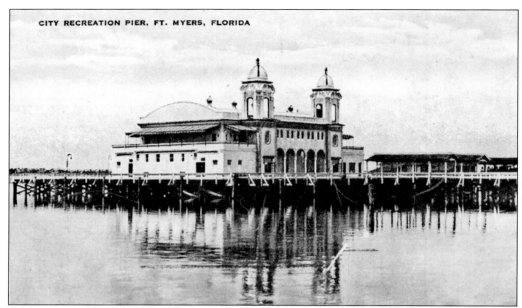

Young and old came to the "Pleasure Pier" for dancing, concerts, political rallies, and shows. The Moorish-style structure was completed at city expense ($48,000) in 1927. When its piers fatigued in 1943, the auditorium portion was taken ashore and installed on Edwards Drive. During World War II, area servicemen used it as a social center. Today it is known as the Hall of Fifty States.

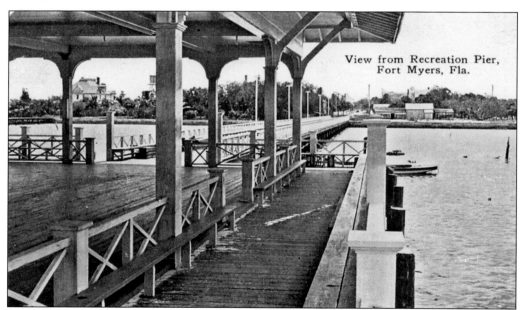

View from Recreation Pier, Fort Myers, Fla.

Another popular pier in Fort Myers was build at the foot of Fowler Street in 1913. Fort Myers stationer James Parker offered this postcard for sale in his Hendry Street shop in the early 1940s. How much Parker charged is not known, but a domestic postage stamp was then one cent. (Collection of Sara Nell Gran.)

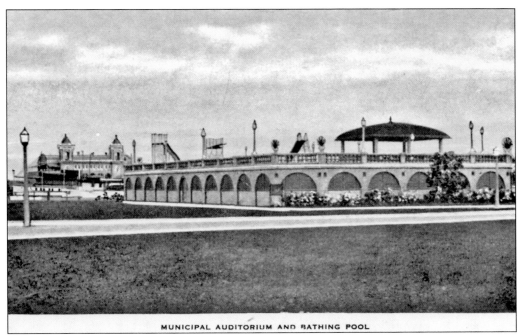

MUNICIPAL AUDITORIUM AND BATHING POOL

Evans Park in Fort Myers included several amenities, including this municipal swimming pool. There was also lawn bowling, volleyball courts, tennis courts, and miniature golf links. In the distance lay the Pleasure Pier.

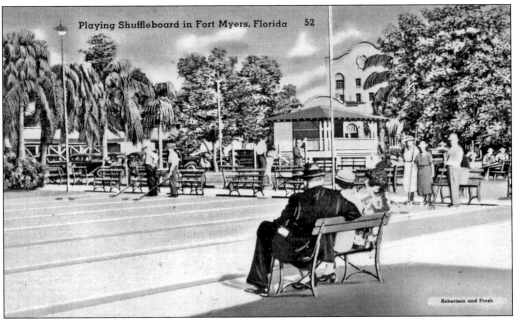

Playing Shuffleboard in Fort Myers, Florida 52

Robertson and Fresh

Shuffleboard was once an exclusive shipboard activity, but when the leisure-time pursuit came ashore, players rejoiced. Shuffleboard courts were installed at the Evans Park complex in 1933. (Collection of Sara Nell Gran.)

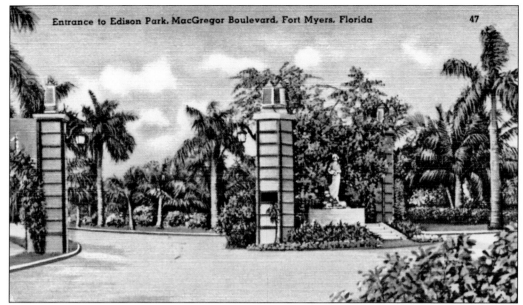

Edison Park, an attractive real-estate subdivision, opened in April 1926 and was partly developed by James Newton. Its McGregor Boulevard entrance, close to the Edison home, included a statue—a nude Grecian maiden. Edison's wife, Mina, complained to Newton, who ordered the sculptor to wrap his creation in a veil. He did.

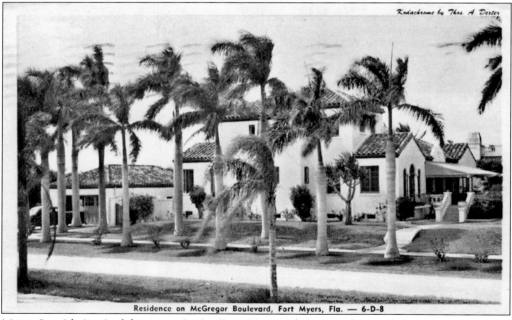

Residence on McGregor Boulevard, Fort Myers, Fla. — 6-D-8

Many Spanish-inspired homes exist in Fort Myers. This example was located on McGregor Boulevard, a thoroughfare known throughout the world. Most were constructed with concrete blocks sheathed in an exterior skin of stucco, painted white to reflect the sun's rays. The roof was bedecked with multi-colored clay tiles.

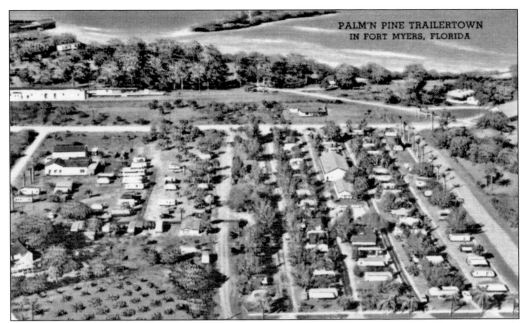

Countless folk came to Florida in the 1920s and 1930s by car, with house trailers in tow. Locals often called them "tin-can tourists." This 1938 postcard depicts the Palm-n-Pine Trailer Camp, which offered both shady and sunny lots, along with city water and sewer hook-ups.

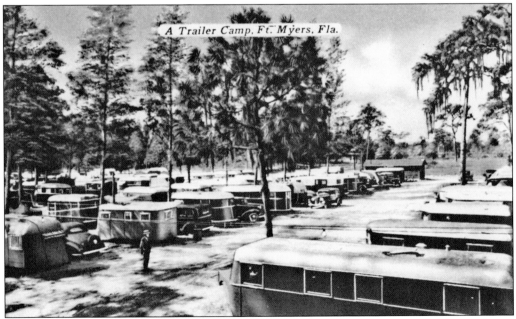

Several trailer camps prospered in Fort Myers, though the precise location of this one is not known. At night, renters often gathered around campfires for storytelling and fiddle music.

WHAT'S DOIN'

in Fort Myers and Southwest Florida

March 8, 1926

PICTURESQUE FLORIDA

Published Weekly **Send One Home**

This publication circulated in Fort Myers during the land boom. It was published weekly and contained timely news about the region and a bevy of ads, which covered printing costs. Theater listings were included, as well as a religious column and news about who was in town. If newspapers were more to your liking, one could choose from the *Fort Myers Press*, the *Tropical News,* or the *Daily Palm Leaf*. In 1931, the first two papers merged to form the *Fort Myers News-Press*.

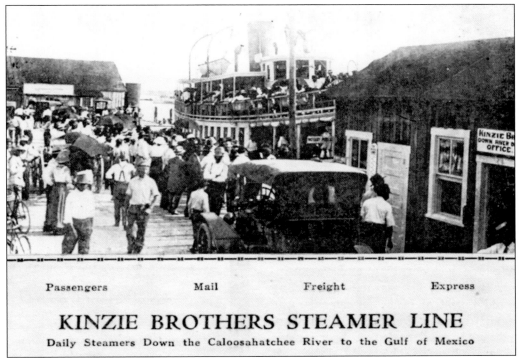

Passengers Mail Freight Express

KINZIE BROTHERS STEAMER LINE
Daily Steamers Down the Caloosahatchee River to the Gulf of Mexico

Several companies offered steamboat services out of Fort Myers. The Kinzie brothers, Andrew and George, operated a very successful firm, as did the Menge brothers, Fred and Conrad. The former operated from City Dock, and by the looks of this postcard, business was thriving.

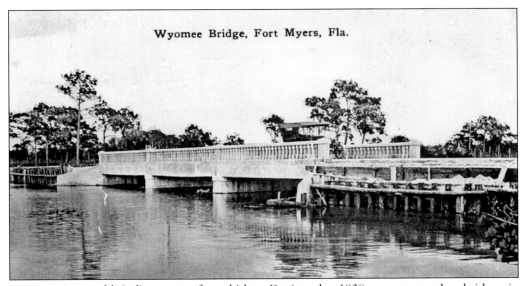

Wyomee Bridge, Fort Myers, Fla.

Wyomee is an old Indian name for whiskey. During the 1930s, many wooden bridges in Fort Myers were replaced with ones of concrete, thanks to funds from the WPA, including this one on McGregor Boulevard. Eventually Wyomee was anglicized to Whiskey Creek. (Collection of Sara Nell Gran.)

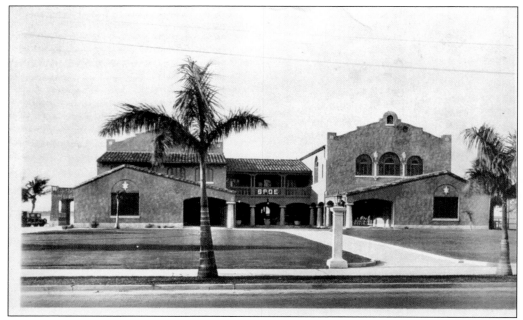

The substantial First Street home of the Benevolent Protective Order of Elks was later used as a Town Club for tourists, a U.S.O. facility for servicemen, and the first Edison College. It also housed Rabe Wilkinson Post #38 of the American Legion. (Collection of Sara Nell Gran.)

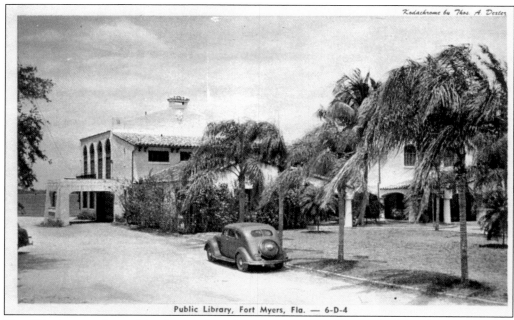

The Elks home, pictured in the previous image, was eventually acquired by the City of Fort Myers. It even once housed the public library, as this postcard confirms. The Caloosahatchee River lay in the background. (Collection of Sara Nell Gran.)

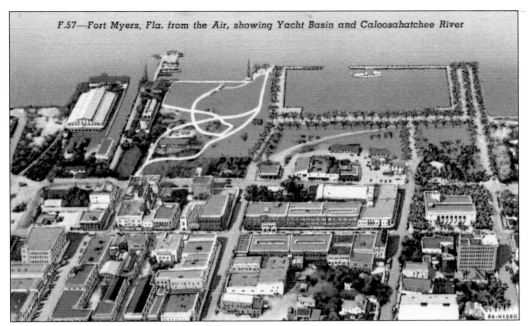

F.57—Fort Myers, Fla. from the Air, showing Yacht Basin and Caloosahatchee River

In the right background is the famous Yacht Basin in Fort Myers, which was built during the Depression and funded by the WPA. It eliminated rickety docks at the waterfront as well as crumbling seawalls and derelict buildings. The $300,000 project, which generated many jobs, was begun in 1937 and lasted two years.

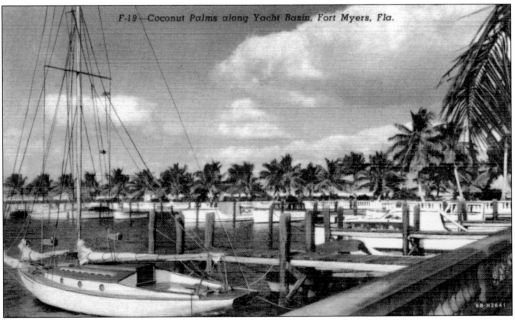

F-19—Coconut Palms along Yacht Basin, Fort Myers, Fla.

Coconut trees were eventually planted near the Yacht Basin. All manner of craft have utilized the refuge, from runabouts to ocean-going yachts. Seawalls insulate vessels from river activity. Over the decades, the attraction has tripled in size.

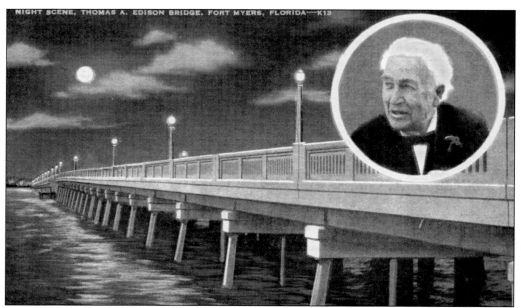

The Great Depression was gripping the nation when the Edison Bridge opened in October 1930. Formal dedication ceremonies were delayed until February 11, 1931, on the occasion of Edison's 84th birthday. The concrete structure cost $500,000 and provided many jobs, but it first lacked lights—an Edison invention! They were added in 1937.

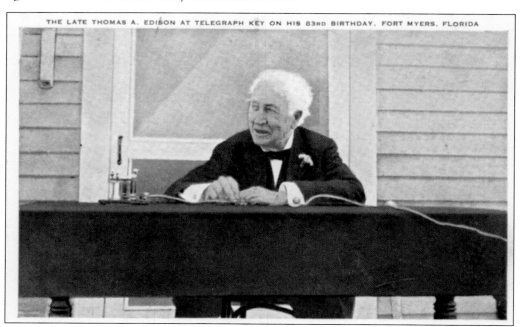

THE LATE THOMAS A. EDISON AT TELEGRAPH KEY ON HIS 83RD BIRTHDAY, FORT MYERS, FLORIDA

Edison was in Fort Myers for his 83rd birthday in 1930, as this postcard notes. Since boyhood he had always been fascinated with the telegraph. World fame hardly altered the inventor's personality. He died on October 18, 1931, and his memory is still greatly revered in Fort Myers. Mina Edison, his wife, died in 1947.

70

IN FLORIDA

The Sky is ever bluest
And friendship is the truest
And enemies the fewest—
 In Florida

Sunshine is the brightest,
Merry hearts are the lightest,
And moonbeams are whitest—
 In Florida

Blue lakes are the clearest,
Home-hearts are the dearest,
And heaven is the nearest—
 In Florida

Maidens are the sweetest,
Sailboats are the fleetest,
And bungalows the neatest—
 In Florida

Sea-bathing here is funny
The beach is fine and sunny
And it's worth your money—
 In Florida

Evergreens are greenest,
Beach-Sand is the cleanest
And Yankees are the leanest-
 In Florida

Grass Widows are the tamest
Bachelors the lamest,
And tarpons the gamest—
 In Florida

Lovers are the boldest,
Oranges are the goldest,
And people live the oldest—
 In Florida

COPYRIGHT, ASHEVILLE POST CARD CO.

Waxing poetic over Florida's attractions was the theme of this postcard. It was available at countless retail outlets. (Collection of Sara Nell Gran.)

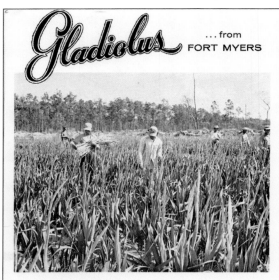

Gladiolus ...from FORT MYERS

Southwest Florida • *Gladiolus Center of the World*

GROWERS AND DISTRIBUTORS

- SCHULTZ BROTHERS
 5111 McGregor Boulevard, Fort Myers, Florida
- NORMAN COX, INC.
 P. O. Box 1831, First Street, Fort Myers, Florida
- ZIPPERER FARMS
 P. O. Box 640, Fort Myers, Florida
- A & W GLADS, INC.
 Fort Myers, Florida

In the 1930s, Fort Myers became the gladiolus center of America. The flower was grown largely in the Iona district of the city. After the "glads" were harvested, sized, and boxed, they were shipped to the distant corners of the country, first by rail, then by airplane and trucks. The industry has largely vanished, and the Iona district is now home to many real-estate subdivisions.

The biggest glad grower in Fort Myers was A & W Bulb Company, founded by Fred Wesemeyer and Donald Alvord. Wesemeyer learned horticulture in his native Frankfurt, Germany. Alvord, of Clearwater, also mastered cut-flowers, and before long the pair had 200 acres under cultivation. Their key to success was mass production.

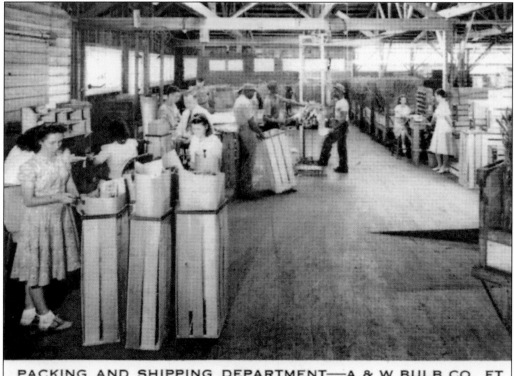

PACKING AND SHIPPING DEPARTMENT—A & W BULB CO., FT.

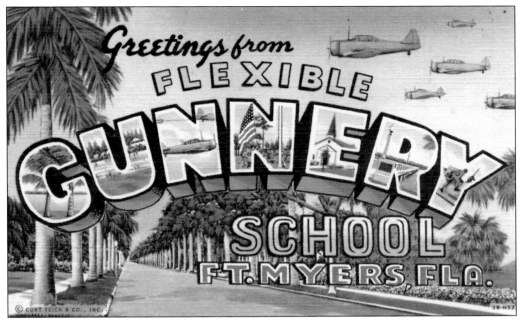

Several military installations were located near Fort Myers during World War II. Greatest of all was the flexible gunnery school at Buckingham. It began with a meager office in the Collier Arcade in May 1942. Before long, a sprawling base arose with thousands of servicemen who trained on turret and waist guns used on Army Air Force bombers.

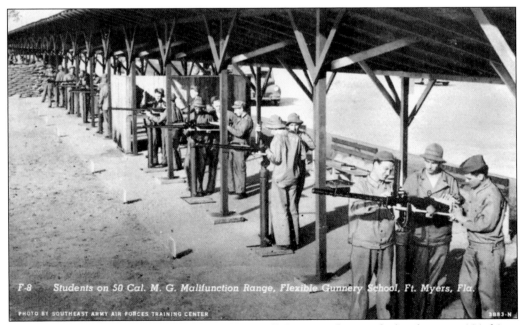

F-8 Students on 50 Cal. M. G. Malifunction Range, Flexible Gunnery School, Ft. Myers, Fla.

PHOTO BY SOUTHEAST ARMY AIR FORCES TRAINING CENTER

The backside of this postcard, sent in 1944, says it all: "Here we have to find and correct 101 things wrong with the gun and tell what would happen in actual combat." After graduation, gunners were usually sent overseas, including the author's father.

73

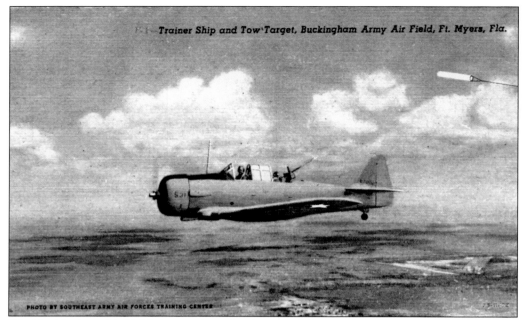

The Buckingham Air Field also conducted training in fighter craft, as this postcard depicts. Once airborne, gunners fired at a moving target.

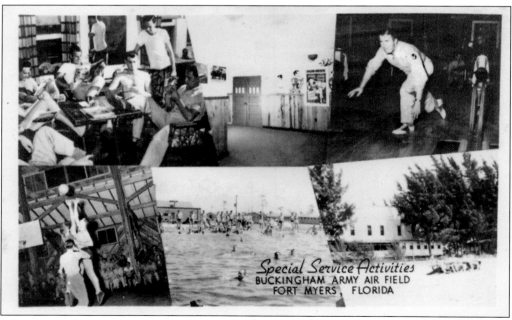

When time off was granted, servicemen took advantage of base facilities or made their way into Fort Myers, where several organizations hosted activities. In this way, many learned about the charms of Fort Myers, and after the war, some returned to live, work, and raise families.

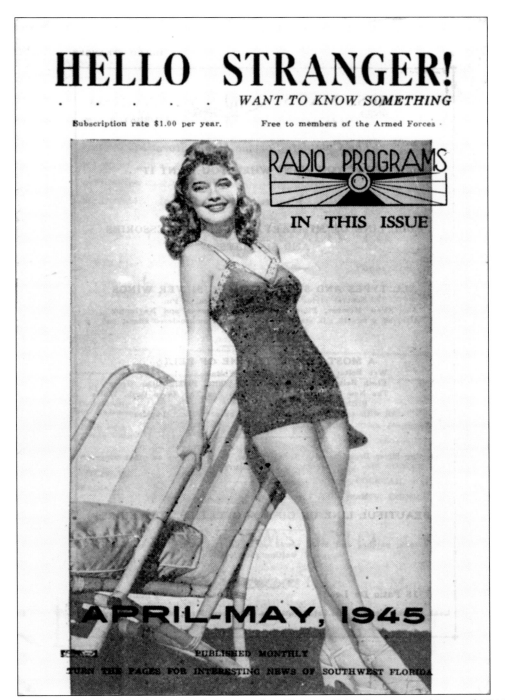

This guidebook, started by former Red Cross worker Florence Fritz, first appeared in April 1944. Her intent was to create something that made servicemen welcomed in Fort Myers. It proved so popular that its publication continued after the war. At its height, the booklet was sent out to 43 states and several foreign countries. Fritz also sold real estate.

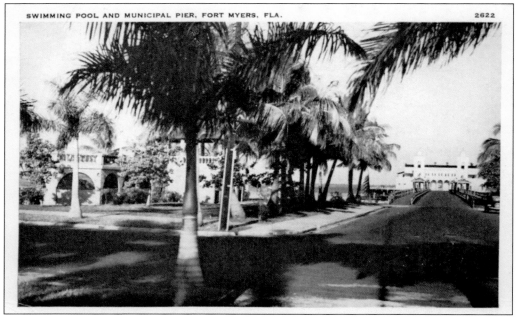

A colorized postcard of the Evans Park pool appears on page three. This one utilizes an actual black–and–white photograph. The pool complex is at the left shrouded in royal palms. The postcard was issued after the start of World War II, but before 1944, when the Pleasure Pier building was brought ashore.

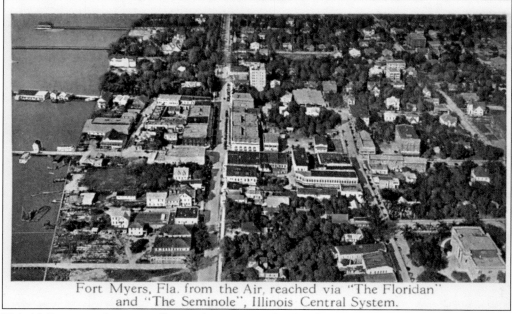

Fort Myers, Fla. from the Air, reached via "The Floridan" and "The Seminole", Illinois Central System.

This 1940s postcard was actually an advertisement for the Illinois Central Railroad, whose trains connected with those of the ACL so as to reach Fort Myers. Many folks from the Midwest used the service, and in this way they discovered the City of Palms. (Collection of Sara Nell Gran.)

76

Five

THE GOLDEN YEARS?

We steamed up the broad and beautiful Caloosahatchee. Along the river cattle grazed neck-deep in floating hyacinths. Snowy egrets frosted the dark green of the jungled mangrove. Countless thousands of the blue-billed ducks whirled and circled in long festoons against the sunset sky.

—Karl P. Abbott, *Open For the Season*

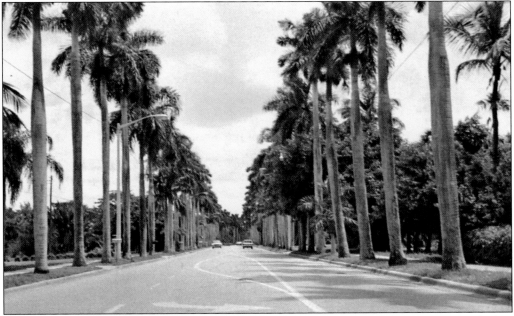

Countless views of McGregor Boulevard have appeared on postcards. This one, taken in the late 1950s, clearly shows the royal palms for which the thoroughfare is noted. An ongoing city chore is keeping the trees in a healthy, disease-free condition.

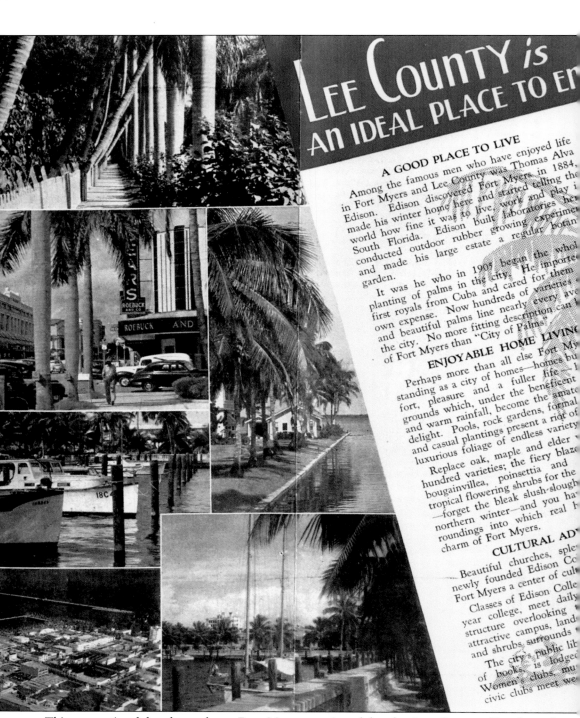

LEE County is AN IDEAL PLACE TO En

A GOOD PLACE TO LIVE

Among the famous men who have enjoyed life in Fort Myers and Lee County was Thomas Alva Edison. Edison discovered Fort Myers in 1884, made his winter home here and started telling the world how fine it was to live, work and play in South Florida. Edison built laboratories here, conducted outdoor rubber growing experiments and made his large estate a regular botanical garden.

It was he who in 1905 began the whole planting of palms in the city. He imported the first royals from Cuba and cared for them at his own expense. Now hundreds of varieties of fine and beautiful palms line nearly every avenue in the city. No more fitting description can be of Fort Myers than "City of Palms."

ENJOYABLE HOME LIVING

Perhaps more than all else Fort Myers is standing as a city of homes—homes built for comfort, pleasure and a fuller life — homes on grounds which, under the beneficent sunshine and warm rainfall, become the amateur's delight. Pools, rock gardens, formal gardens and casual plantings present a riot of luxurious foliage of endless variety.

Replace oak, maple and elder with the hundred varieties; the fiery blaze of the bougainvillea, poinsettia and other tropical flowering shrubs for the pines—forget the bleak slush-slough of northern winter—and you have the surroundings into which real home charm of Fort Myers.

CULTURAL ADV

Beautiful churches, splendid newly founded Edison Coll Fort Myers a center of cult

Classes of Edison Colle year college, meet daily structure overlooking attractive campus, land and shrubs surrounds t

The city's public libr of books is lodged Women's clubs, mu civic clubs meet we

This promotional brochure about Fort Myers was issued by the Lee County Chamber of

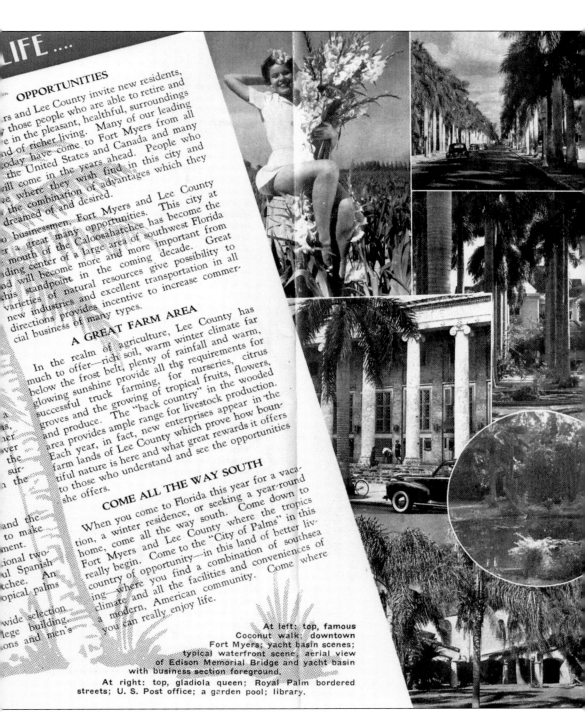

LIFE....

OPPORTUNITIES

...rs and Lee County invite new residents, ...y those people who are able to retire and ...re in the pleasant, healthful, surroundings ...nd of richer living. Many of our leading ...oday have come to Fort Myers from all ...the United States and Canada and many ...will come in the years ahead. People who ...re where they wish find in this city and ...the combination of advantages which they ...dreamed of and desired.

...o businessmen. Fort Myers and Lee County ...r a great many opportunities. This city at ...mouth of the Caloosahatchee has become the ...ding center of a large area of southwest Florida ...nd will become more and more important from ...this standpoint in the coming decade. Great ...varieties of natural resources give possibility to ...new industries and excellent transportation in all ...directions provides incentive to increase commer- ...cial business of many types.

A GREAT FARM AREA

In the realm of agriculture, Lee County has much to offer—rich soil, warm winter climate far below the frost belt, plenty of rainfall and warm, glowing sunshine provide all the requirements for successful truck farming, for nurseries, citrus groves and the growing of tropical fruits, flowers, and produce. The "back country" in the wooded area provides ample range for livestock production. Each year, in fact, new enterprises appear in the farm lands of Lee County which prove how boun- tiful nature is here and what great rewards it offers to those who understand and see the opportunities she offers.

COME ALL THE WAY SOUTH

When you come to Florida this year for a vaca- tion, a winter residence, or seeking a year-round home, come all the way south. Come down to Fort Myers and Lee County where the tropics really begin. Come to the "City of Palms" in this country of opportunity—in this land of better liv- ing—where you find a combination of southsea climate and all the facilities and conveniences of a modern, American community. Come where you can really enjoy life.

At left: top, famous
Coconut walk; downtown
Fort Myers; yacht basin scenes;
typical waterfront scene; aerial view
of Edison Memorial Bridge and yacht basin
with business section foreground.
At right: top, gladiola queen; Royal Palm bordered
streets; U. S. Post office; a garden pool; library.

Commerce in 1958.

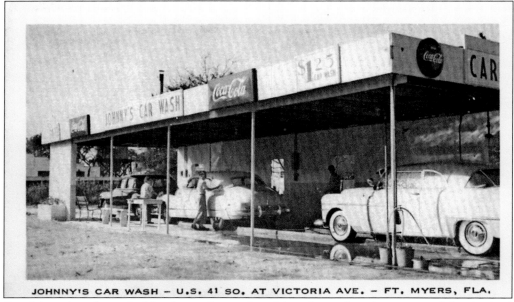

JOHNNY'S CAR WASH – U.S. 41 SO. AT VICTORIA AVE. – FT. MYERS, FLA.

Fort Myers has always had its share of carwashes. Johnny's stood at the corner of the Tamiami Trail (U.S. 41) and Victoria Avenue. And Johnny's slogan? "We Make 'Em Spiffy In Justa Jiffy." (Collection of Sara Nell Gran.)

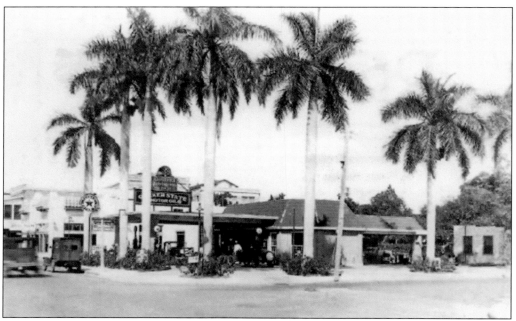

This Fort Myers service station dispensed Texaco gas and Quaker State Oil products. Like Johnny's Car Wash, much of the repair work was conducted out-of-doors or under a carport.

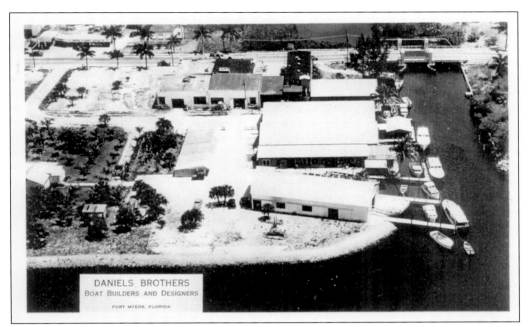

Daniels Brothers was a prominent boat builder in Fort Myers. Their facility cornered Billy's Creek and the Caloosahatchee River on what became Palm Beach Boulevard. (Collection of Sara Nell Gran.)

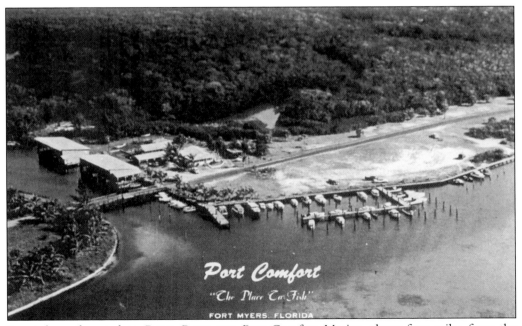

Located on the road to Punta Rassa was Port Comfort Marina, about four miles from the intersection of McGregor and San Carlos Boulevards. The marina performed repairs and offered painting, docking, tackle, bait, cold drinks, Texaco marine products, and a "free outdoor boat ramp." (Collection of Sara Nell Gran.)

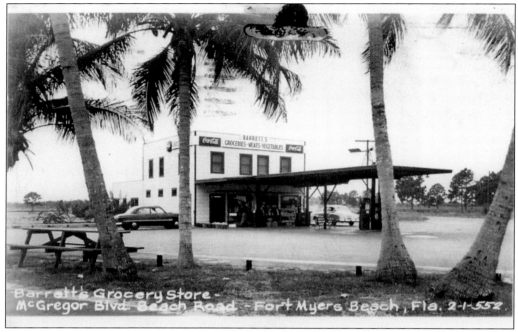

No 7-Elevens existed in Fort Myers when this postcard photograph was taken in 1959. Nevertheless, you could purchase gas here, as well as snacks, basic food items, and, of course, Coca-Cola. It was a perfect place for beach treats! (Collection of Sara Nell Gran.)

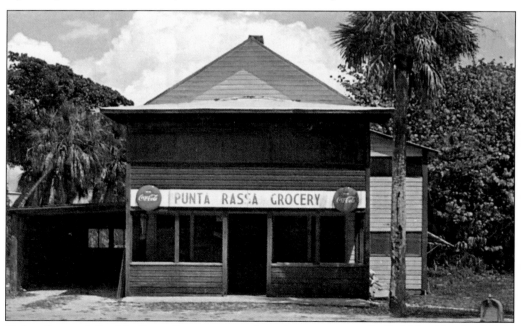

Only a few souls lived in Punta Rassa proper, where the causeway to Sanibel Island begins. Likely all found the Punta Rassa Grocery most convenient. Enticing roadside signs foretold of its location. Customers also included those waiting for the Sanibel Island ferryboat.

Businesses often produced maps and guides, as this 1955 example attests.

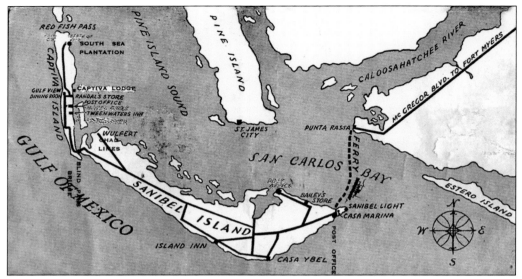

The ferryboat to Sanibel Island departed from Punta Rassa. For decades, the year-round service was provided by the Kinzie Brothers Steamer Line. In 1963, the automobile causeway opened, and development of the island, along with neighboring Captiva, started in earnest.

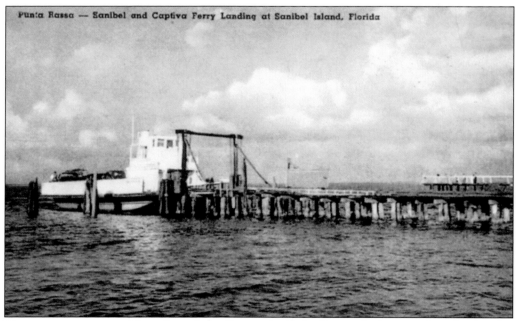

How many passengers ultimately took the ferry to Sanibel will never be known. Over the decades, different vessels performed the service. The crossing of San Carlos Bay was usually uneventful, unless, of course, winds or storms prevailed.

"It's right on the beam"

There's friendliness in the simple phrase, "Have a Coke". It turns strangers into friends . . . Coca-Cola stands for the pause that refreshes — has become the high-sign of kindly-minded people around the world.

FORT MYERS

Coca-Cola

TRADE MARK REGISTERED

BOTTLING COMPANY

Fort Myers, Florida Telephone 197

Like most Florida cities, Fort Myers had its own Coca-Cola bottling plant. Glass bottles belonging to the facility had the words "Fort Myers" emblazoned on the underside. Today they are collectors' items.

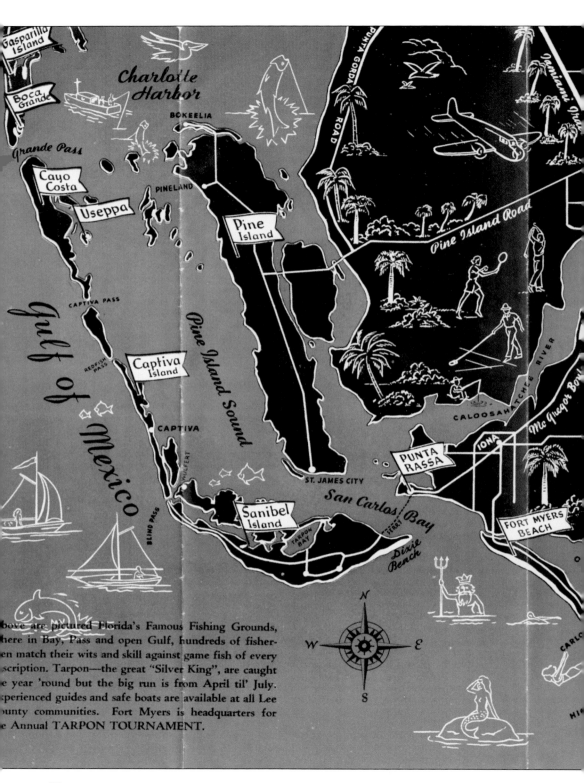

Gasparilla Island

Boca Grande

Charlotte Harbor

BOKEELIA

Grande Pass

Cayo Costa

Useppa

PINELAND

Pine Island

PUNTA GORDA ROAD

Pine Island Road

CAPTIVA PASS

Gulf of Mexico

REDFISH PASS

Captiva Island

Pine Island Sound

CAPTIVA

WULFERT

BLIND PASS

ST. JAMES CITY

CALOOSAHATCHEE RIVER

McGregor Boul

IONA

Sanibel Island

TARPON BAY

San Carlos Bay

FIRST ST

Dixie Beach

PUNTA RASSA

FORT MYERS BEACH

Tamiami Tra

bove are pictured Florida's Famous Fishing Grounds,
here in Bay, Pass and open Gulf, hundreds of fisher-
en match their wits and skill against game fish of every
scription. Tarpon—the great "Silver King", are caught
e year 'round but the big run is from April til' July.
xperienced guides and safe boats are available at all Lee
ounty communities. Fort Myers is headquarters for
e Annual TARPON TOURNAMENT.

N
W · E
S

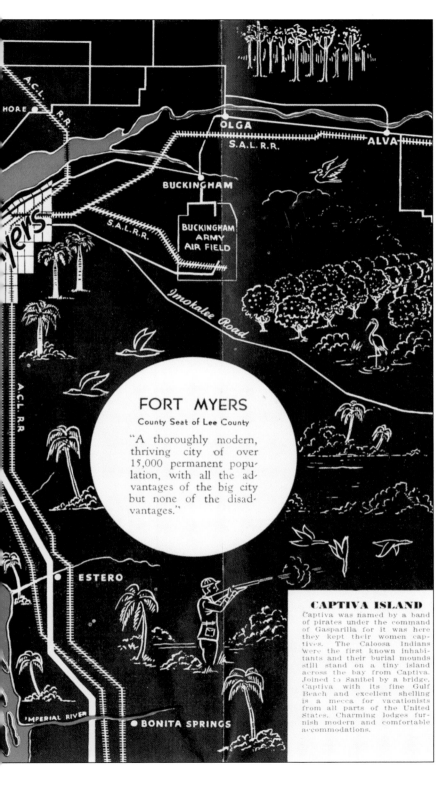

A.C.L. RR

HORE

OLGA

ALVA

S.A.L. R.R.

BUCKINGHAM

S.A.L.R.R.

BUCKINGHAM
ARMY
AIR FIELD

Imokalee Road

yers

A.C.L RR

FORT MYERS

County Seat of Lee County

"A thoroughly modern, thriving city of over 15,000 permanent population, with all the advantages of the big city but none of the disadvantages."

ESTERO

A.C.L. RR

CAPTIVA ISLAND

Captiva was named by a band of pirates under the command of Gasparilla for it was here they kept their women captives. The Caloosa Indians were the first known inhabitants and their burial mounds still stand on a tiny island across the bay from Captiva. Joined to Sanibel by a bridge, Captiva with its fine Gulf Beach and excellent shelling is a mecca for vacationists from all parts of the United States. Charming lodges furnish modern and comfortable accommodations.

IMPERIAL RIVER

BONITA SPRINGS

This c. 1945 map depicts most every locale and attraction of Lee County. Then, as now, the county's seat of governance was Fort Myers.

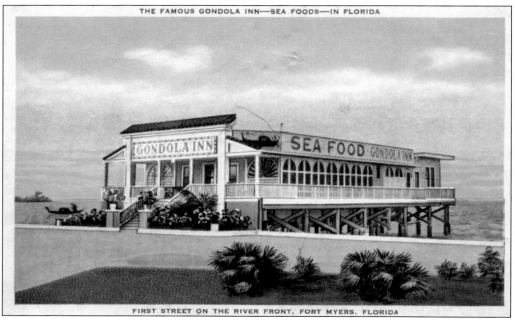

Restaurants have always abounded in Fort Myers. The Gondola Inn, located on West First Street, catered to a large and loyal clientele. It sat on pilings overlooking the Caloosahatchee River.

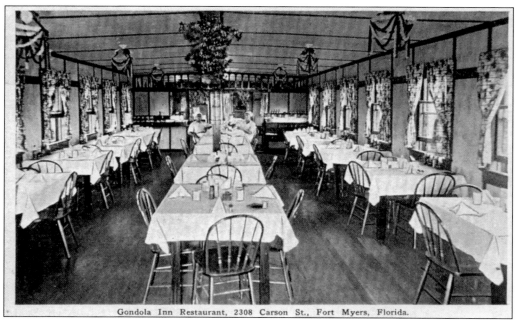

Almost every table in the Gondola Inn came with a river view. Seafood was king, and the restaurant's reputation for preparing it was legendary. River breezes were free. (Collection of Sara Nell Gran.)

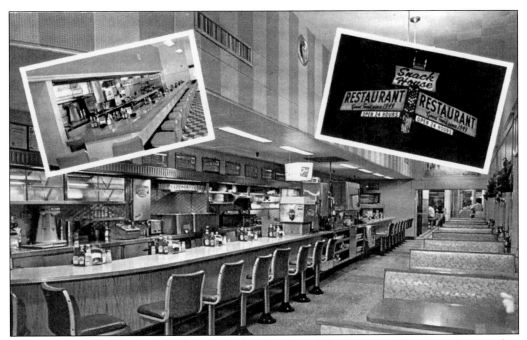

The Snack House was located inside the Collier Arcade, at First Street and Broadway. It catered to both locals and transients, and a cup of coffee was 5¢. Win Ellis opened the establishment in 1946, and it was the first city eatery to have air-conditioning. (Collection of Sara Nell Gran.)

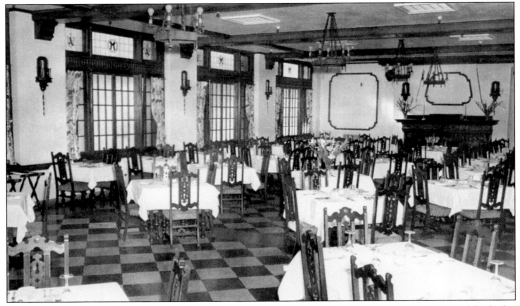

Dining at the Hotel Morgan in Fort Myers was always a pleasant occasion. Linen tablecloths, crystal, and real silverware were in evidence, and the menu offered many selections. (Collection of Sara Nell Gran.)

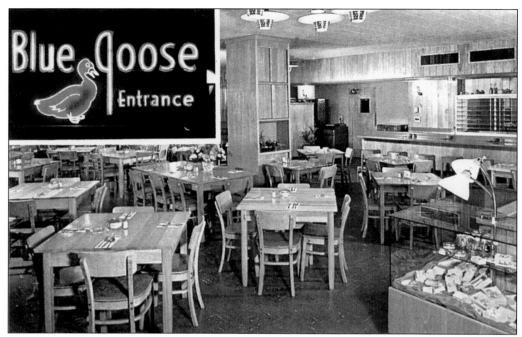

Located on Lee Street and opened in 1925, the Blue Goose was operated by Lula Lindenmuth and Alma Wells. The atmosphere was informal, and the food was excellent and reasonably priced. (Collection of Sara Nell Gran.)

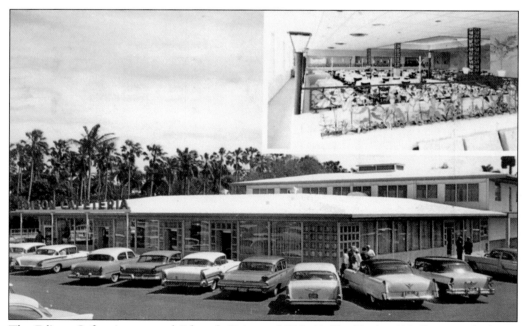

The Edison Cafeteria cornered Edwards Drive and U.S. 41 (the Tamiami Trail). Its easily found location attracted more than one passing motorist. Western beef was featured as well as native vegetables, along with homemade pastries and breads.

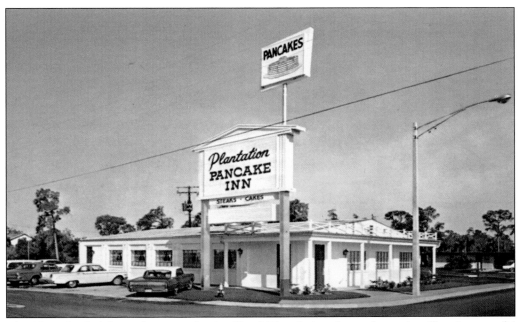

The Plantation's claim to fame was that it offered 27 varieties of pancakes and waffles. A successful breakfast operation led the way to lunches and dinners. It was located at 3630 Cleveland Avenue, the city's name for its part of the Tamiami Trail.

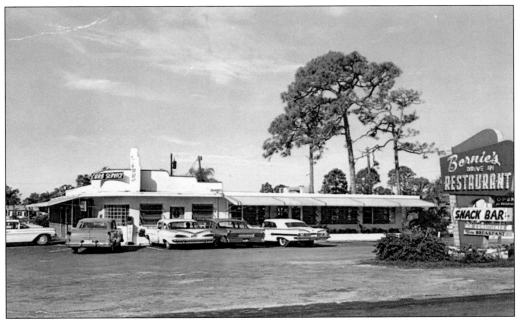

Hot kosher corned beef and homemade pies were served up at Bernie's. It, too, sat along Cleveland Avenue. Another Bernie's outlet was located in Milwaukee.

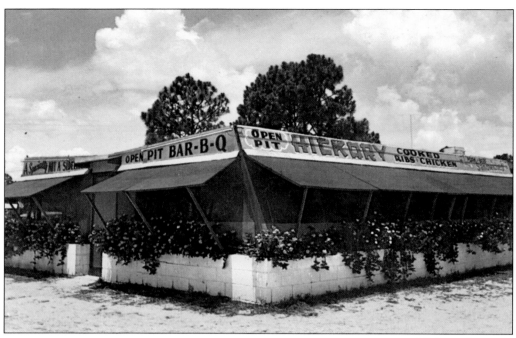

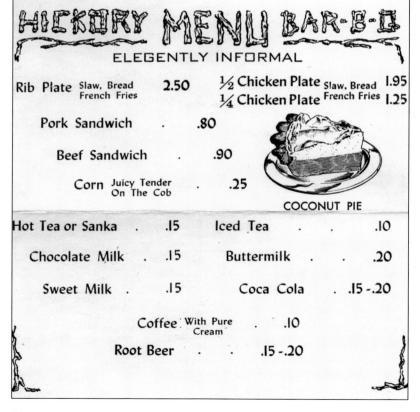

HICKORY MENU BAR-B-Q

ELEGENTLY INFORMAL

Rib Plate Slaw, Bread French Fries	**2.50**	½ Chicken Plate Slaw, Bread French Fries **1.95**
		¼ Chicken Plate **1.25**
Pork Sandwich .	**.80**	
Beef Sandwich .	**.90**	
Corn Juicy Tender On The Cob .	**.25**	

COCONUT PIE

Hot Tea or Sanka .	**.15**	Iced Tea . .	**.10**
Chocolate Milk .	**.15**	Buttermilk . .	**.20**
Sweet Milk .	**.15**	Coca Cola .	**.15 -.20**
	Coffee With Pure Cream .	**.10**	
	Root Beer . .	**.15 -.20**	

Hickory Bar-B-Q, at the intersection of McGregor and San Carlos Boulevards, once prepared its fare over an open pit burning hickory wood. Folks ate at picnic tables and were ably cared for by the Davis clan. The pies were just as famous as the ribs. A modern building was eventually built, but just lately this popular eatery closed.

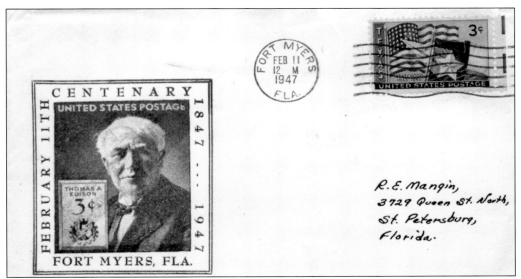

This cachet was mailed from Fort Myers on February 11, 1947. It commemorates the 100th anniversary of the birth of Thomas Edison. It was sold by a Fort Myers philatelist.

A beautiful float rolling down the most beautiful avenue of royal palms in the world

Edison died in 1931, and memorial services were held in Fort Myers in ensuing years. The Woman's Club and Junior Chamber of Commerce wanted to do more, and in 1938, the Edison Pageant of Light began. The event celebrates the inventor's birth, spans several days, and includes a ball and parade. The February affair still draws the multitudes.

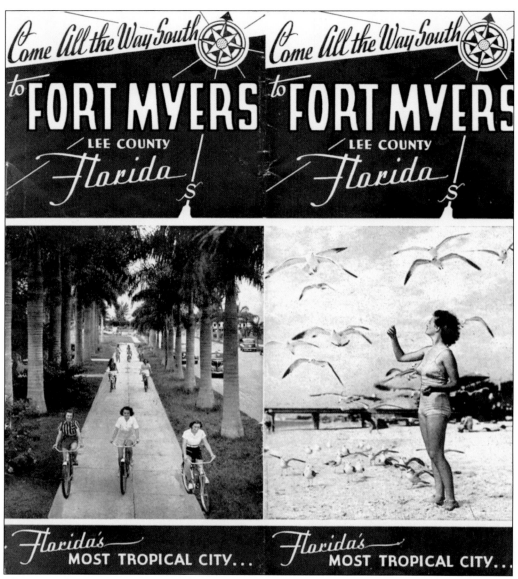

This 1950s brochure was specifically aimed at those winter tourists who normally stayed in the northern portion of the Sunshine State.

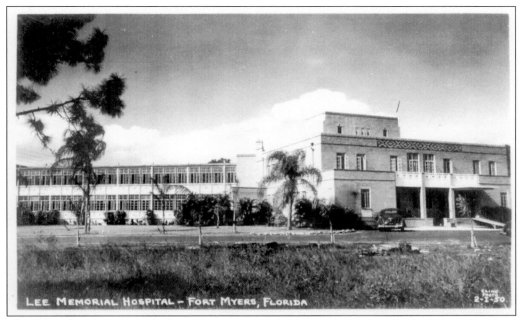

The old Robert E. Lee Hospital appears on page 33. This postcard depicts the facility on Cleveland Avenue (U.S. 41) that opened in 1943. Significant additions have since been added. In time, the name was shortened to Lee Memorial Hospital. Few realize who or what is commemorated. (Collection of Sara Nell Gran.)

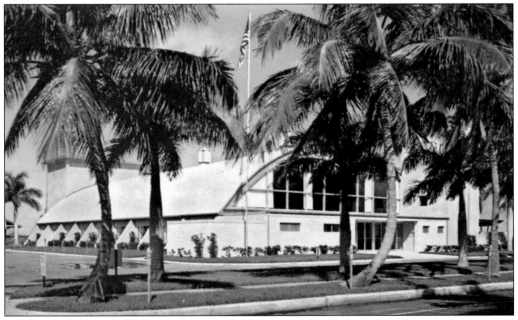

Exhibition Hall in Fort Myers, built in 1955 for $200,000, has hosted a wide variety of events over the decades. It has nearly 10,000 square feet and room for 1,000 people.

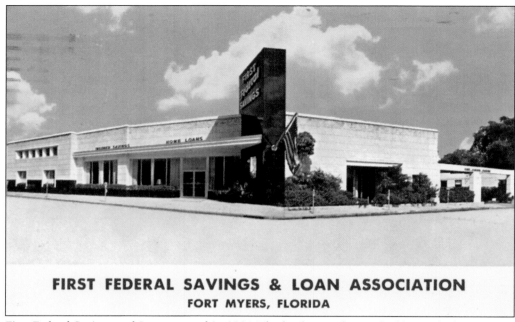

FIRST FEDERAL SAVINGS & LOAN ASSOCIATION
FORT MYERS, FLORIDA

First Federal Savings and Loan opened in 1934. The bank rented several addresses before moving into its own building on First Street in 1949. In 1956, a much larger headquarters opened on Main Street (pictured here) followed by another corporate move to Second Street in 1978.

American drive-in theatres are almost extinct, even though they reigned supreme during the 1940s and 1950s. The movie *Away All Boats* premiered in 1956, and the Fort Myers Drive-In Theatre was quick to show it. But as locals knew, the facility was really in North Fort Myers, on the opposite side of the Caloosahatchee River.

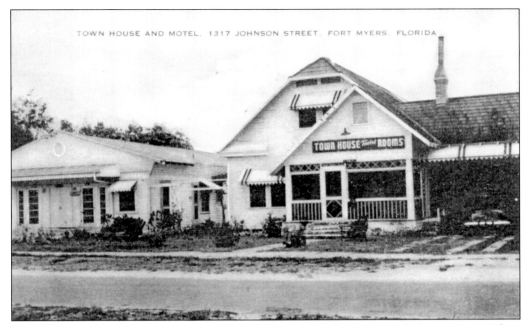

Several homes in Fort Myers were enlarged to accommodate tourists and transients. Often, a side addition did the trick. The Town House and Motel, located on Johnson Street, was a case in point.

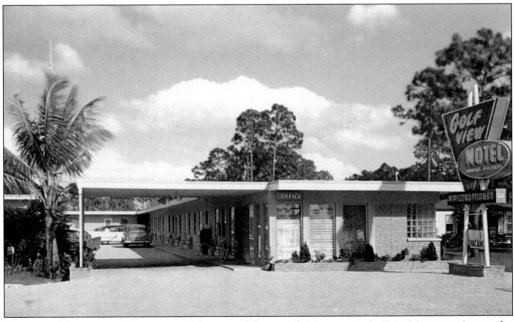

The age of the automobile spawned the age of the motel. Many arose in Fort Myers, owing to the influx of tourists during the winter season. The Golf View, on Cleveland Avenue, advertised itself as the "Most Modern Motel in Town."(Collection of Sara Nell Gran.)

Many travelers linked the Edison name with Fort Myers. The owner of the Edisonian Court Motel, Gibbs Miller, capitalized on the connection. His operation was also located on Cleveland Avenue—the famed Tamiami Trail. A swimming pool and shuffleboard court helped attract customers.

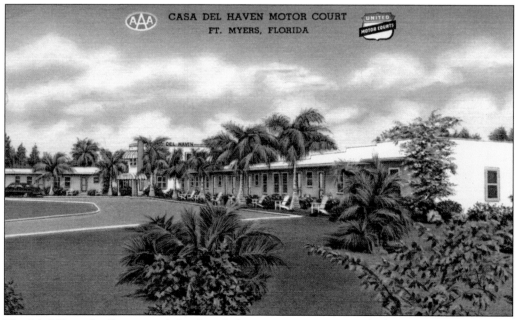

The McAllister family operated the Casa Del Haven Motor Court, which also faced the Tamiami Trail. Twenty rooms were offered to the traveling public. The backside of this postcard notes that many rooms were air-conditioned "by Frigidaire." The motel was favorably rated by AAA.

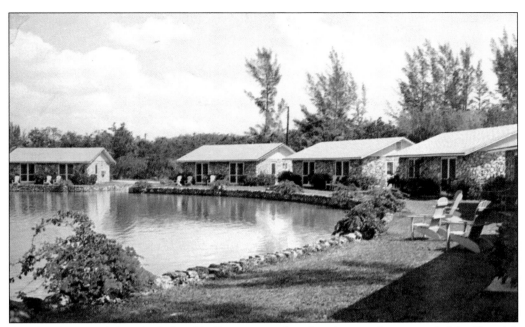

Jimmie Moore and Jimmie Colcord built cottages of coral rock around a manmade lake. Jimmie's Cabins opened in 1947, and later is was renamed Rock Lake Motel. Improvements have been made over the years, and the setting on Palm Beach Boulevard survives.

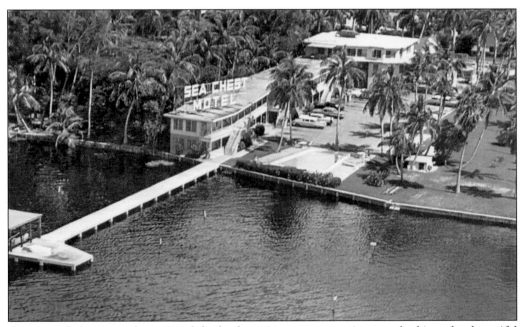

Owners of the Sea Chest Motel built their 31-room operation overlooking the beautiful Caloosahatchee River. Each room was equipped with "Panel Ray Heat" and a telephone. Other amenities at the First Street location included a pool and concrete fishing pier.

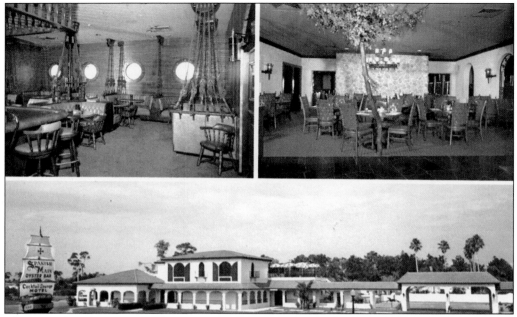

The Spanish Main Motel at 4800 South Cleveland Avenue (Tamiami Trail) had an attractive nautical theme, as the ship suggests. Today "The Trail" is overrun with chain motels, and the two-lane artery of yesteryear now boasts six lanes.

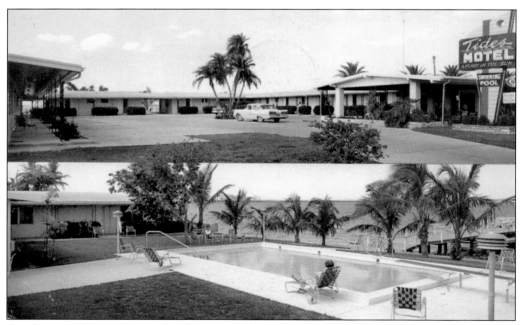

Another popular retreat on First Street was the Tides Motel, which was also backed up to the Caloosahatchee River. The establishment featured the ubiquitous pool as well as a fishing pier. The owners advertised their facility simply as "a place in the sun."

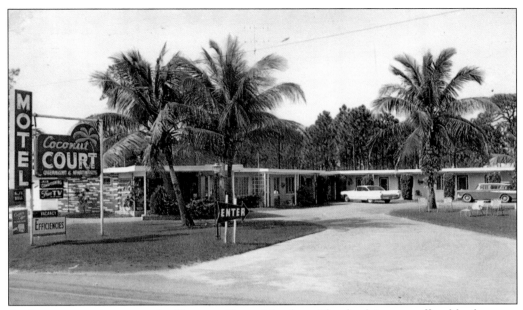

As the entrance sign states, the Coconut Court Motel on Cleveland Avenue offered both rooms and efficiencies. The latter, desired by long-term winter tourists, allowed meals to be prepared in a unit. The front sign also indicates "Free TV"—a reminder that guests once had to feed quarters into a timed meter.

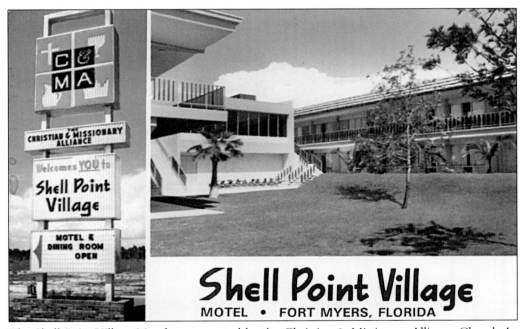

The Shell Point Village Motel was operated by the Christian & Missionary Alliance Church. Its superb riverside location, off McGregor Boulevard, attracted guests from around the country. Today, Shell Point is the largest life-care retirement community in Florida, having nearly 1,800 residents.

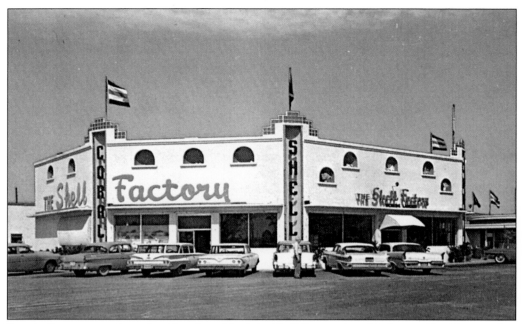

Practically every tourist and resident has visited the Shell Factory, but this famous Florida attraction is really located in North Fort Myers, miles north of the City of Palms. Harold Crant started out in Bonita Springs in 1938. When his shell store was destroyed by fire in 1951, the move was made to North Fort Myers. (Collection of Sara Nell Gran.)

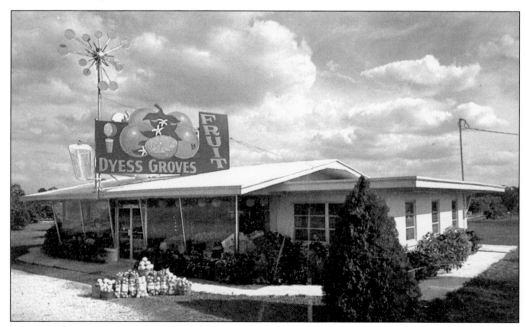

Dozens of grove stands once dotted Lee County. Dyess Groves was located on Rt. 80 in East Fort Myers, near Hickey Creek. Citrus could be bought by the piece or bag or even sent home. The firm's slogan was, "We Grow 'em, Pack 'em and Ship 'em."

Six

FORT MYERS BEACH

It is no ad-writers dream that all the fine people at "The Beach" go out of their way to make a visit there enjoyable. Nowhere in the world will one find more courteous or friendly people. Leave your tuxedo at home.
— *Tropical Guide* magazine, November 1953

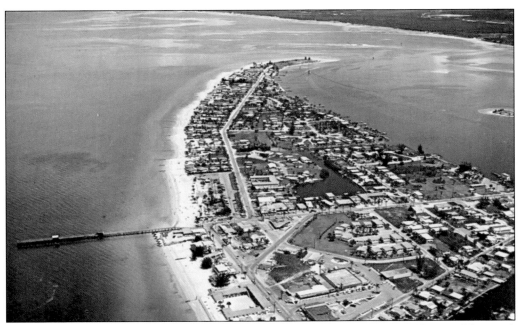

Fort Myers Beach is another crown jewel of Southwest Florida. The beach itself, one of the state's safest, is located on Estero Island, and is reachable from Fort Myers by bridge. Early on it was called Crescent Beach, for the island resembles a crescent moon. Tourists and vacationers from all parts of the globe rejoice in the setting.

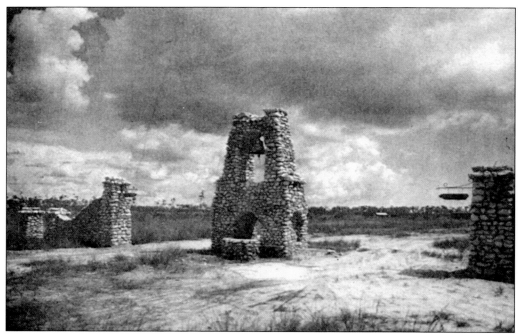

The so-called "Beach Road" (San Carlos Boulevard) departed McGregor Boulevard at today's Miners Plaza. In bygone years, stone arches with a bell tower pointed the way. The arches were erected by Fort Myers Beach developer Tom Phillips. In 1921, the sandy trail was finally paved.

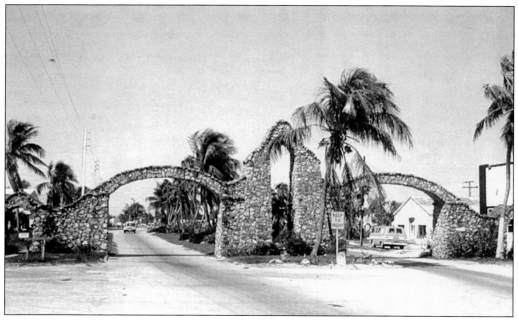

Another set of rustic stone arches stood on the Beach Road at the southern tip of San Carlos Island, which separates the mainland from Fort Myers Beach proper. Again, Tom Phillips performed the work in hopes of attracting real-estate customers.

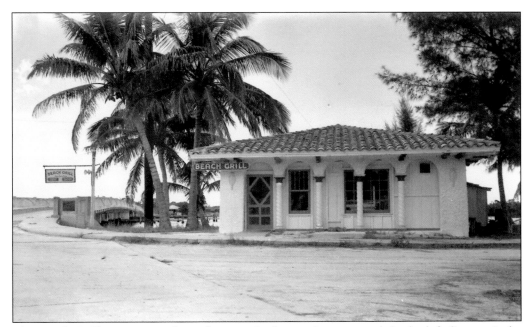

The Beach Grille sat next to the arches seen in the previous postcard. In the left distance is the swing drawbridge leading to Fort Myers Beach. This was the second such bridge to span Matanzas Pass. The so-called "Sky Bridge" of 1979 now handles the traffic.

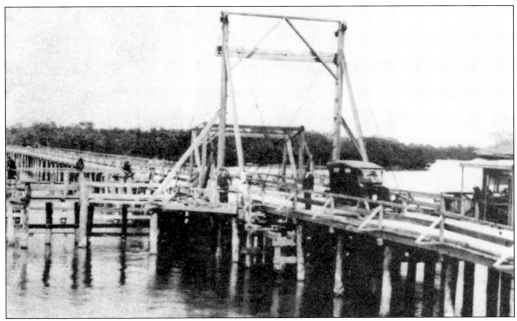

This postcard depicts the first drawbridge over Matanzas Pass. The Crescent Beach Road & Bridge Company opened it in 1921, and the toll was 54¢. A few years later, Beach Road was paved northwards to McGregor Boulevard (near today's Miners Plaza) and eventually renamed San Carlos Boulevard.

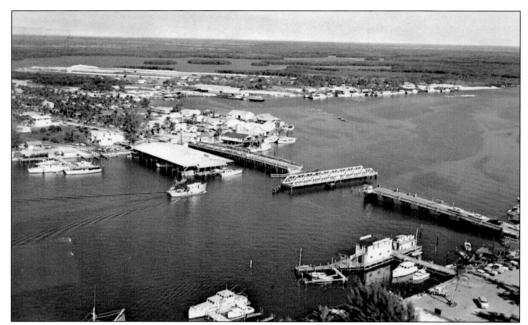

This aerial view clearly shows San Carlos Island (left background) and Fort Myers Beach (lower right). The second drawbridge over Matanzas Pass is in the open position, and traffic has temporarily halted. The Sky Bridge of 1979 was built alongside this drawbridge, and piers of the latter remain to this day.

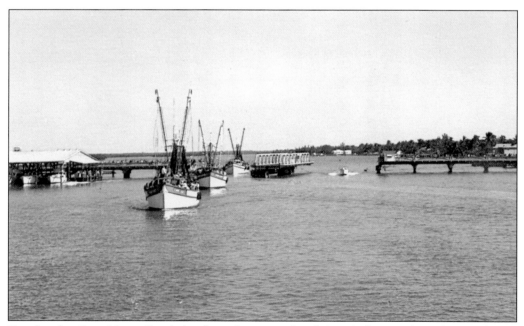

For decades, Fort Myers Beach has been home to the shrimp industry of Southwest Florida. Numerous trawlers tie up here, and several processing facilities are located on San Carlos Island. Vessels often depart together and part ways once they are out in the Gulf of Mexico.

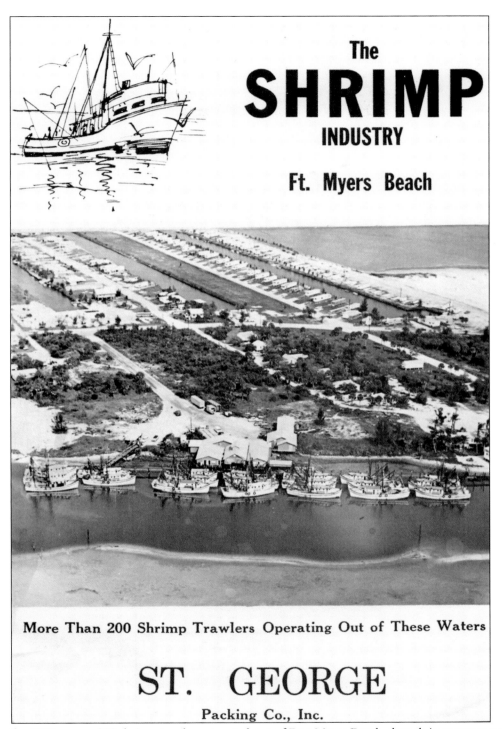

The SHRIMP INDUSTRY

Ft. Myers Beach

More Than 200 Shrimp Trawlers Operating Out of These Waters

ST. GEORGE

Packing Co., Inc.

In the 1960s, some 200 shrimp trawlers operated out of Fort Myers Beach, though in recent years that number has greatly lessened. The St. George Packing Company was a major player.

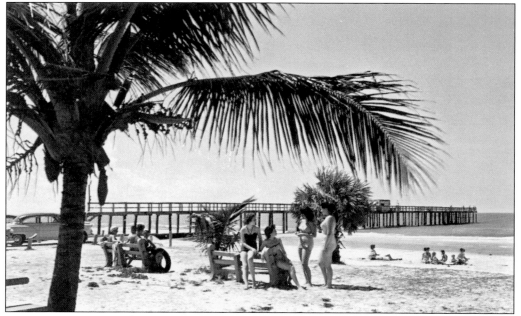

How many vacationers have walked the fishing pier at Fort Myers Beach will never be known. Its length and appearance has changed over the decades, owing to storm damage. First built of wood, today the structure is comprised of concrete. A shaded pavilion graces the tip.

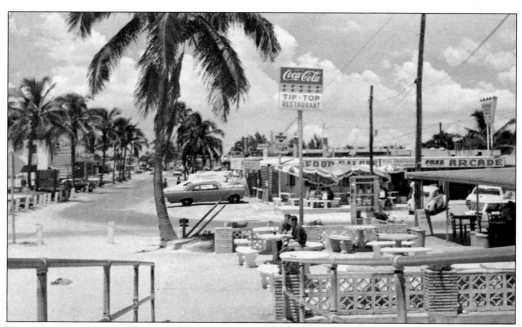

The photographer for this 1960s postcard is standing on the pier at Fort Myers Beach. Times Square lay in the foreground, where cars were once permitted. In recent years this quadrant of the beach has become a "pedestrian friendly" zone.

COMING TO FORT MYERS BEACH

A NEW SHERATON INN

to be located at the south end of the beach a short distance north of the new causeway. The Inn will have over 600 feet of private beach, and all rooms will have view of the Gulf of Mexico. During construction, we will maintain a trailer on the property, which will be staffed every day. Why not stop and let us show you the rendering and floor plans of The Inn. Spend next season at the new Sheraton Estero Island Inn. Make your reservation now!

SHERATON MOTOR INN

ESTÉRO ISLAND

+ **110 UNITS**

+ **COMPLETE FACILITIES**

+ **OPENING FALL 1968**

Fort Myers Beach has experienced record growth and development in recent years. High-rise condos permeate the landscape where once only modest cottages and trailer parks existed. Numerous motels and hotels have risen as well, as this Sheraton announcement of 1968 confirms.

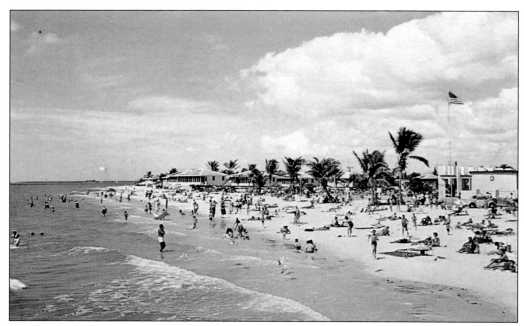

Sun, fun, and relaxation are watchwords at Fort Myers Beach. The sand is soft and the waters have no dangerous undertow. A pounding surf, as found on Florida's east coast, is rare. This postcard was printed for Garl's Drug Store, for years an institution on "FMB."

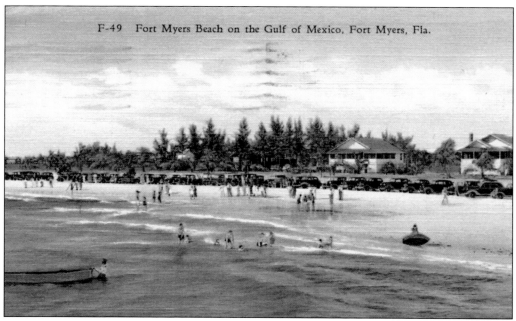

During the 1930s and 1940s, one could park their car on Fort Myers Beach. Estero Island was far less crowded then. Eats and drinks could be obtained at several nearby establishments, but most folks just brought along a picnic basket.

Seven

HERE AND THERE

Why settle for only two weeks in Florida when you can have forever?
—Bill Stern, "Dean of American Sportscasters," promoting Cape Coral, 1960

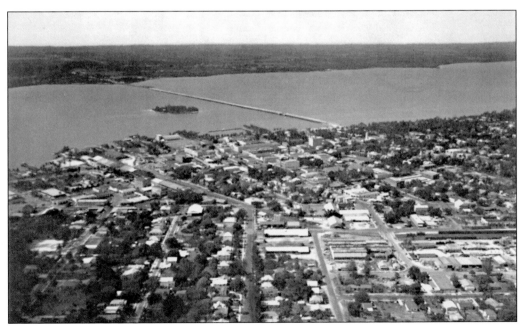

This aerial image of Fort Myers looks to the north. The downtown district is the immediate foreground, and the Caloosahatchee River and North Fort Myers lay in the distance. Lofton Island, once inhabited, is plainly visible, as is the Edison Bridge, which was dedicated in the inventor's presence in 1931.

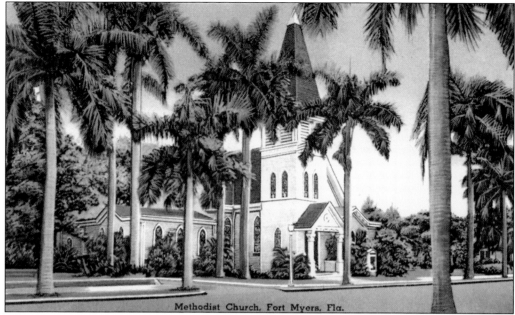

Methodist Church, Fort Myers, Fla.

Even churches in Fort Myers have experienced record growth. In 1872, a Methodist church "circuit rider" conducted a service here. A few years later, in 1881, a Methodist church building was consecrated on First Street. The congregation continued to grow, and a larger facility—seen in this postcard—arose in 1903. But even this structure eventually proved inadequate, especially in the postwar economy. Another new facility was conceived, and the building seen in the image below opened in 1953. Royal palms beautify the entrance setting. The famed Royal Palm Hotel (page 42) once stood across the street.

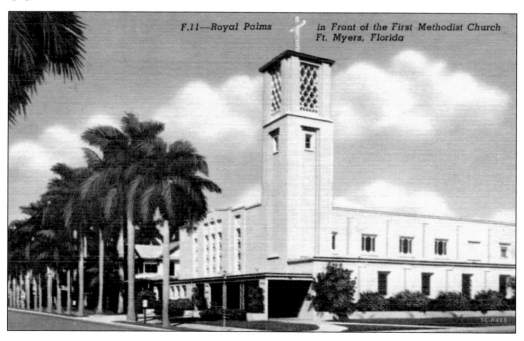

F.11—Royal Palms in Front of the First Methodist Church Ft. Myers, Florida

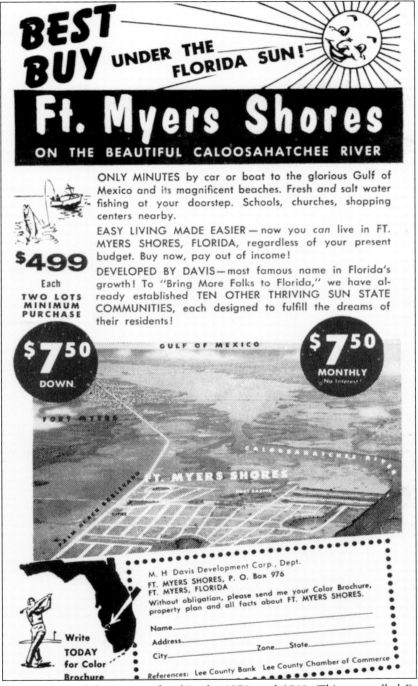

Many new real-estate subdivisions surfaced in the 1950s and 1960s. This one, called Fort Myers Shores, proved inviting owing to its closeness to the Caloosahatchee River. Back then, a single lot cost just $499, though a minimum of two had to be purchased. And what terms! $7.50 down and $7.50 monthly with no interest.

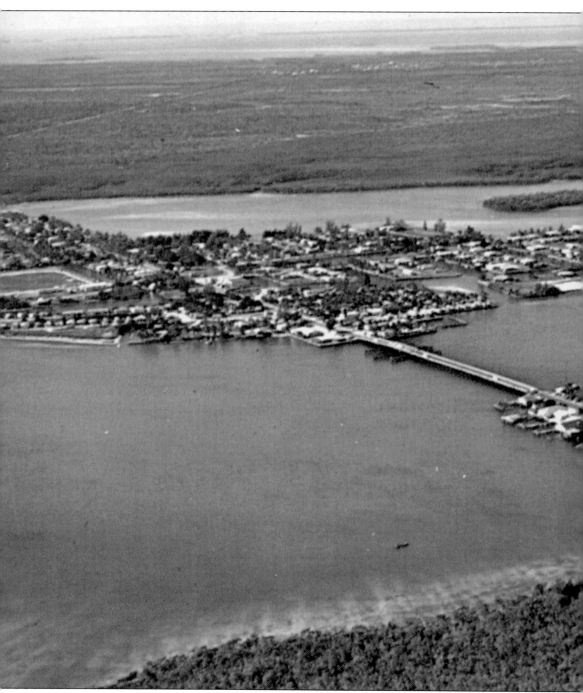

The backside of this postcard reads, "The Matlacha Section of Fort Myers, Florida." In reality, though, Matlacha was a fishing village located on Pine Island Road (Route 78), far removed from downtown Fort Myers. Matlacha is really an island standing between the mainland and Pine Island. By saying it was near Fort Myers, the postcard recipient got an immediate idea where

the setting was situated. This aerial was snapped in 1966, and in the distance one can see Pine Island. This peaceful quadrant of Lee County, where life was once so laid back, seems poised for unprecedented development.

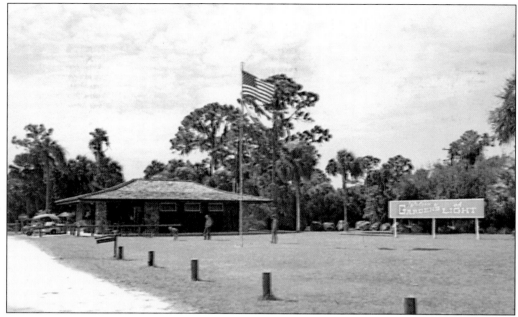

Over 100 acres comprised the Garden of Light, once a popular tourist attraction of Fort Myers. Visitors viewed the tropical setting by walking down illuminated trails. The so-called Fountain of Light was bathed in a rainbow of colors. The Rock of Light revolved. One trail at this tourist stop recreated a scene in the Everglades.

This postcard illustrates two great attractions of Fort Myers: the wide and beautiful Caloosahatchee River in the downtown district and the warm, inviting Gulf waters of Fort Myers Beach. Few cities can make a similar claim.

116

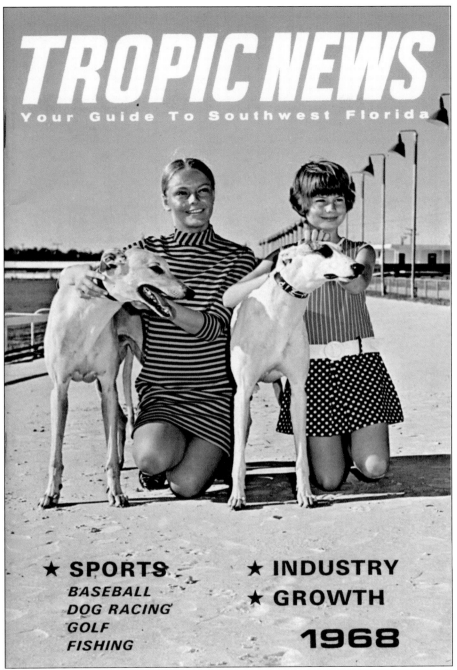

TROPIC NEWS

Your Guide To Southwest Florida

★ **SPORTS**
BASEBALL
DOG RACING
GOLF
FISHING

★ **INDUSTRY**
★ **GROWTH**

1968

Many publications have appeared over the decades that have touted Fort Myers, Lee County, and Southwest Florida. This 1968 issue of *Tropic News* contained information about the region, attractions, accommodations, restaurants, etc., along with timely articles. The preponderance of ads paid printing costs and boosted profits. Distribution was the key, however, and they were usually free for the taking at leading retail establishments—just as they are today.

117

An automobile causeway connecting Fort Myers at Punta Rassa with Sanibel Island opened on May 26, 1963. It cost $2.7 million. This postcard, printed just after the grand opening, confirms how little developed Punta Rassa really was. The tollbooths are faintly visible at lower left. Not a condo or hotel is in sight! Palm trees and rest stops along the causeway are also absent,

though the drawbridge can be plainly seen. The barrier island of Sanibel, another crown jewel of Southwest Florida, lay in the distance. Would Sanibel be more interesting if the causeway had never been built?

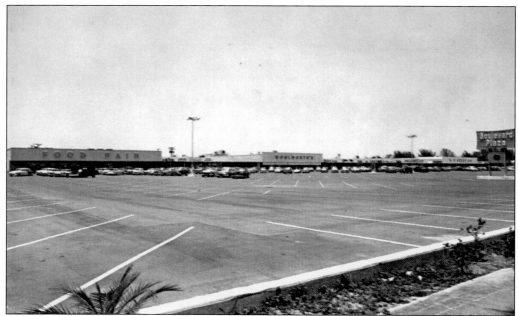

Shopping centers abound in the Fort Myers area. Boulevard Plaza, the city's first, was located on McGregor Boulevard. Much fanfare accompanied its late-1950s opening. Shoppers can be fickle, and over the decades the Boulevard's appeal slipped. Today the site seen here has been leveled, ready for a new development chapter.

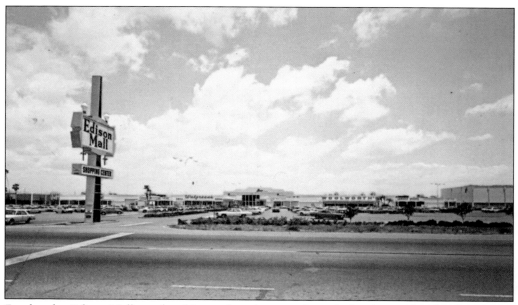

For decades, Edison Mall was the ultimate shopping experience in Southwest Florida. The project's prime mover was businessman George Sanders. This view shows the complex in its early days. Today, its preeminent position is being challenged, especially since two super malls are being built south of Fort Myers.

120

The block lettering on this postcard allowed scenes to be inserted within each letter. This particular card was mailed from Fort Myers in 1963, when the population was comprised of 25,000 people. As this book goes to press, about 52,500 people call Fort Myers home, while more than 500,000 reside in Lee County.

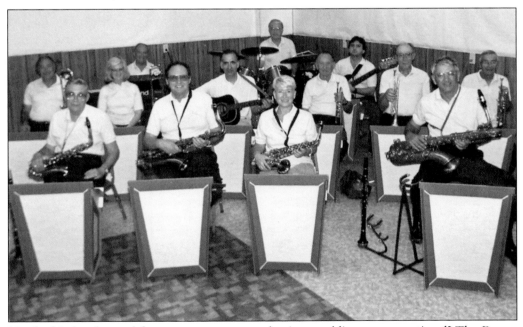

Need a big band sound for your next party, graduation, wedding, or promotional? The Bunny Hanson Band of Fort Myers could help. From Goodman to Dorsey, from Duke Ellington to Artie Shaw, Bunny's group played it all. Here is another example of how a postcard could be used for advertising.

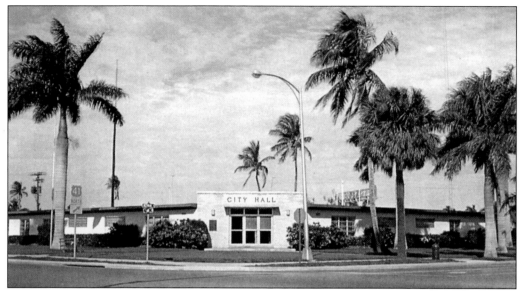

City Hall was located in this $75,000 building from 1954 to 1973. When its snazzy $1.3 million replacement opened in 1973 at Second and Hendry, the Fort Myers police department remained in the building of old—that is until their Peck Street headquarters were completed in 1984. (Collection of Sara Nell Gran.)

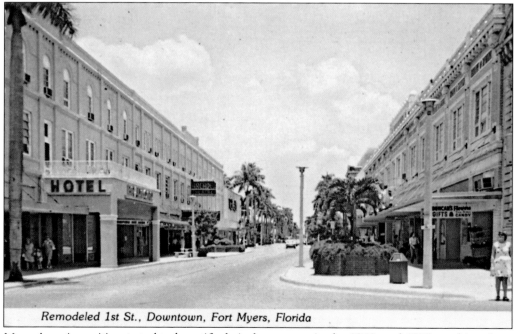

Remodeled 1st St., Downtown, Fort Myers, Florida

Many American cities started to beautify their downtowns in the 1960s and 1970s, making them more "pedestrian friendly" and "green." That which occurred on First Street in Fort Myers (seen here) helped but did not stop the retail migration to outside the city. Now, in 2005, a downtown renaissance of historic proportions is emerging.

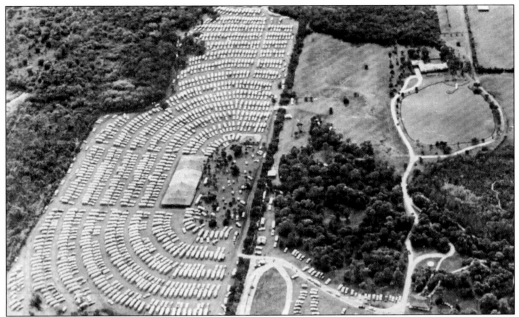

All manner of entertainment events have been staged in Southwest Florida. In 1966, owners of Air Stream house trailers converged upon Fort Myers for a nationwide rally. It took place on the grounds of the Garden of Light, an attraction pictured on page 116. (Collection of Sara Nell Gran.)

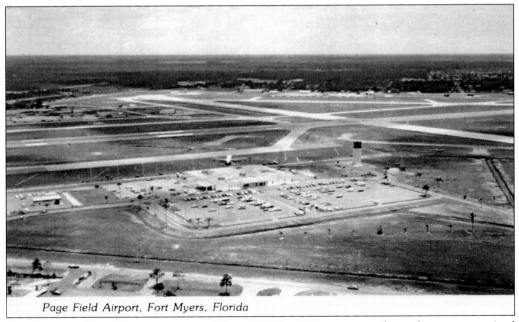

Page Field Airport, Fort Myers, Florida

The airport at Fort Myers was renamed Page Field in 1941, one year after sod runways received concrete. A surge in air travelers prompted construction of a new facility. Southwest Florida International, located off Daniels Parkway, opened in 1983. (Collection of Sara Nell Gran.)

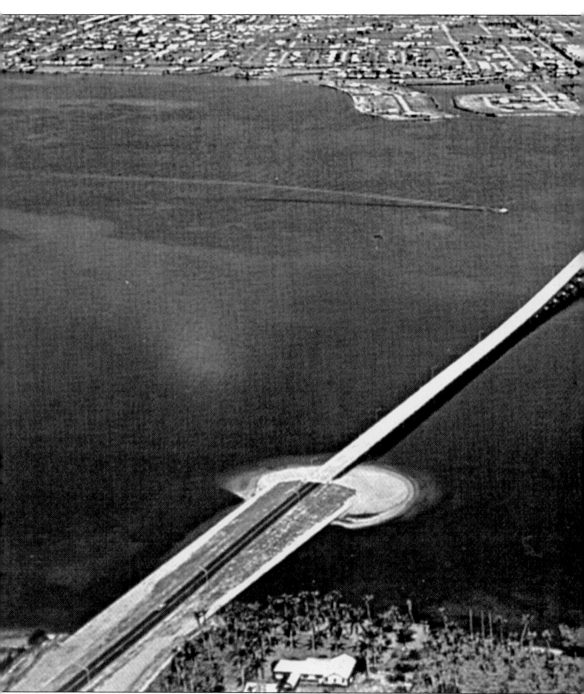

Driving from downtown Fort Myers to nearby Cape Coral was once a circuitous affair. All this changed in 1963, when the Cape Coral Bridge opened over the Caloosahatchee River. Today, the 114-square-mile community is the second largest city in Florida geographically, the 12th largest in population. This postcard appeared shortly after the bridge opened. In the foreground is the

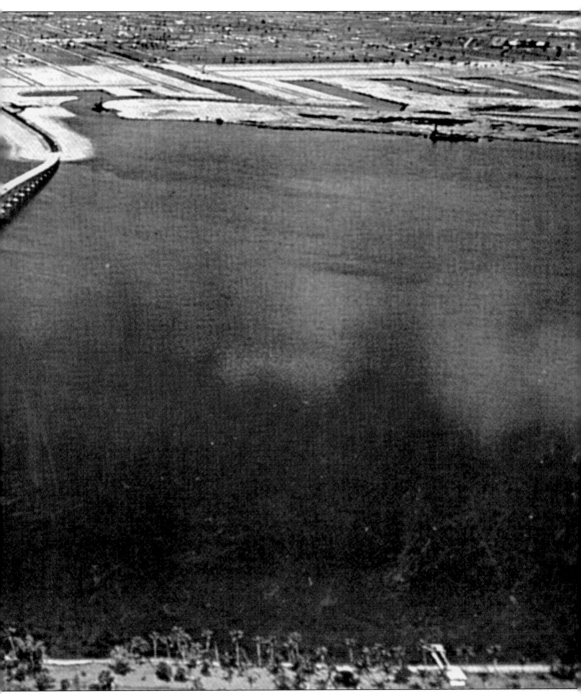

College Park section of Fort Myers. In the distance lay "The Cape" with its 400 miles of canals. As this image confirms, many parcels north of the bridge are awaiting homes and businesses. (Collection of Sara Nell Gran.)

Want to Trade Climates?

Trade in *YOUR* Northern Home for a Home in Florida at

LEHIGH ACRES

The "WHISTLER"
2 bedroom, 2 bath, screened porch

One of the 11 new models now on display from $7,800 to $19,000
For free transportation from Fort Myers call EDison 4-2500 ext. 141

TRUE VALUE GUARANTEED HOME TRADE IN PROGRAM

Now available in most Northern States. For information on how the plan works write:

Harry C. Powell, Jr., P. O. Box 573, LEHIGH ACRES, Florida 33936

LEHIGH ACRES

Lehigh Acres, east of Fort Myers, began as a postwar retirement community. This ad appeared in a 1960s magazine. Lee Ratner, a Chicago businessman, conceived the project in the previous decade. Ratner bought a 20,000-acre parcel in Lee County, called it Luckey Lee Ranch, and later subdivided it into affordable lots. The rest is history.

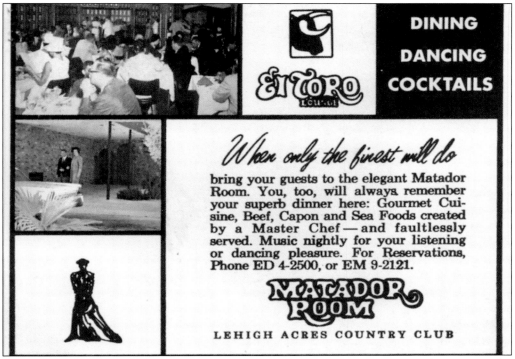

The Matador Room at Lehigh Acres Country Club was a popular dining spot in the 1960s, as this ad suggests. Over the decades, many other restaurants have moved to "The Acres," satisfying the needs of the ever-growing list of newcomers and old timers.

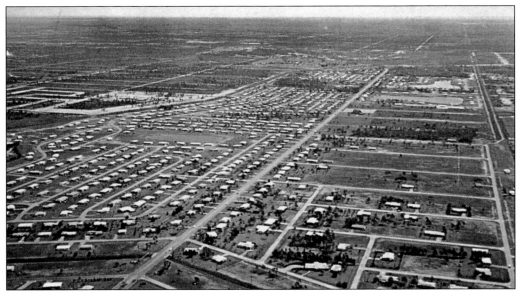

This aerial of Lehigh Acres, looking east from Fort Myers, was taken in 1969. Many streets still await housing. In 2000, some 33,000 people resided in The Acres. Many folks bought their parcels from Ratner's Lehigh Corporation.

FORT MYERS—YOU ARE MY HOME!

FLOWERING FLORIDA; ocean-edged, lake-dotted and sunshine-soaked; breezed and fanned with water-cooled winds, fresh from their playground o'er Gulf and Ocean; with no mountain range to halt and hold rain-laden clouds, humidity is gone—banished, it seems, by the foresight of Nature's intention. Eons ago was a dirge chanted at the funeral of chill and cheerless weather.

Four hundred miles further south than San Diego and yet no farther east than Cleveland, snuggling next the edge of Caloosahatchee's rippling waters; a short ride from the opalescence of the Gulf, is my home—Fort Myers. Nearby lie the beaches that are your setting, sloping borders of a shell-sand fringe—pounded to powder by the ceaseless waves of centuries of Time.

O'erhead a deep blue heaven, specked with fluffy clouds driven by the never-failing winds of the semi-tropic trades; an ethereal arch, as a roof for my home, dipping to the west to sink into the myriad colored waters of the gulf—to the east ending in the vast Beyond of the great Atlantic.

A gem-city, rich in a thousand ways—fascinating to the eye; peopled with men and women, home-builders and home-keepers, by the manner of their birth; clean, well planned and managed, graced with Nature's greatest gifts of soil, air, water and vegetation. A thriving, bustling place, wrapt in the healthy fever of rapidly acquired wealth, yet ever awake to the needs of a safe and sane future. Surrounded by marvelous back country—in places muck—the rotted fall of vegetable growth of centuries; muck equal to that of the fertile valley of the Nile.

Road-barred, you have been for years, to the eager, pleasure-seeking pilgrim of America—but now within reach; now shall the northern hordes worn by weary winters and battles of big business, seek out the glories of which they've heard—to revel in them. Rumor of your worth and beauty spreads fast among people of wealth and leisure. Thousands have come, hundreds have stayed and other thousands left but to return again. God hid you within what once was an impassable terrain that the achievement of your finding might be the greater.

But Man came—sturdy leather-handed pioneers with purpose; they came and saw a future, built homes and reared families; hewing and filling, grading the long smooth ribbons of road that have opened the treasure trove to the eager eyes of a waiting world. And the world has come in throngs—and will continue coming—settling here to delight in your glories—to grow still further with you. Some will spend the fortunes won in the stress and battle of business in other parts. Still others farming the rich loamy lands, shall take from out the soft soil-pad that tops your base of rock and coral the wealth of thriving crops.

Your future is assured, your value known. And by the manner of your building you shall be judged. And, soundly built and sanely planned, you shall rise ever higher into your own place in the sun. Fort Myers, where Nature's work is finished, but where Man's has just begun—you are My Home!

Designed and Printed by Tri-Arts Printing Corporation, New York

This interesting ad comes from that 1926 booklet mentioned on page eight. It was prepared at the height of the famed land boom, when a choice real-estate parcel in Fort Myers (or elsewhere in Florida) often sold two or more times in a single day. An illustrated book about that remarkable period in Florida history is long overdue—authors take note!—and when written, much can be penned about what happened in the City of Palms, Lee County, and Southwest Florida.